Eastern Shore
Perspectives

ANTELO DEVEREUX, JR.

Schiffer ®
Publishing Ltd
4880 Lower Valley Road • Atglen, PA 19310

MW00560085

Copyright © 2013 by Antelo Devereux, Jr.

Library of Congress Control Number: 2013932599

All rights reserved. No part of this work may be reproduced or used in any form or by any means—graphic, electronic, or mechanical, including photocopying or information storage and retrieval systems—without written permission from the publisher.

The scanning, uploading, and distribution of this book or any part thereof via the Internet or via any other means without the permission of the publisher is illegal and punishable by law. Please purchase only authorized editions and do not participate in or encourage the electronic piracy of copyrighted materials.

"Schiffer," "Schiffer Publishing, Ltd. & Design," and the "Design of pen and inkwell" are registered trademarks of Schiffer Publishing, Ltd.

Cover and book designed by: Bruce Waters
Type set in Zurich BT

ISBN: 978-0-7643-4446-6
Printed in China

Published by Schiffer Publishing, Ltd.
4880 Lower Valley Road
Atglen, PA 19310
Phone: (610) 593-1777; Fax: (610) 593-2002
E-mail: Info@schifferbooks.com

For our complete selection of fine books on this and related subjects, please visit our website at www.schifferbooks.com. You may also write for a free catalog.

This book may be purchased from the publisher. Please try your bookstore first.

We are always looking for people to write books on new and related subjects. If you have an idea for a book, please contact us at proposals@schifferbooks.com

Schiffer Publishing's titles are available at special discounts for bulk purchases for sales promotions or premiums. Special editions, including personalized covers, corporate imprints, and excerpts can be created in large quantities for special needs. For more information, contact the publisher.

In Europe, Schiffer books are distributed by
Bushwood Books
6 Marksbury Ave.
Kew Gardens
Surrey TW9 4JF England
Phone: 44 (0) 20 8392 8585; Fax: 44 (0) 20 8392 9876
E-mail: info@bushwoodbooks.co.uk
Website: www.bushwoodbooks.co.uk

CONTENTS

Introduction...4

Cecil County..7

Kent County ...11

Queen Anne's County ...22

Caroline County ...26

Talbot County..28

Dorchester County ..49

Wicomico County ..61

Somerset County ..64

Worcester County...77

INTRODUCTION

The Eastern Shore of the Chesapeake Bay – the western shore of the Delmarva Peninsula – is a captivating and environmentally sensitive region, rich with natural beauty, history, and hints of southern hospitality and culture. A glance at a map reveals a land area divided by rivers and creeks that flow into the bay. A series of finger-like peninsulas point southward in the direction of the Susquehanna River's flow. A number of islands trail off from the Hooper Islands and Stradding Point to their north, remnants of a time when water levels were lower and a long peninsula was exposed. The islands are so low on the water that they are reminiscent of Venice (without a city).

The Chesapeake Bay is commonly referred to as the "drowned river," because the rise of ocean levels filled the valley of the Susquehanna and other rivers when the last ice age's glaciers melted. Over time islands have appeared and disappeared as sands have shifted in the currents. On the distant edges of vast marshes, trees can be seen seemingly standing on islands barely above water. In some places a fishing village and its buildings may be found as well. Inland, acres of flat farmland provide crops for people in the growing months and wintering grounds for thousands of geese that in turn attract hunters.

The first humans are believed to have arrived on the peninsula about 8000 to 10,000 years ago. Reportedly these hunters and gatherers were split into two major groups: the Assateague, on the Atlantic Ocean side, and the Nanticoke, on the Chesapeake Bay side. Back then nature's offerings must have been abundant, especially those associated with the water – fish, oysters, crabs, and wildfowl. Evidence of their cultures remains in the form of a few descendants, shell middens, archaeological sites, and historical markers.

The English appeared in the Chesapeake with Captain John Smith and the Virginia Company, chartered in 1606 by King James I. With the Jamestown colony in Virginia as a base, Smith explored the bay and its Eastern Shore. By the 1632 Charter of Maryland, King Charles I of England granted "all that Part of the Peninsula, or Chersonese, lying in the Parts of America, between the Ocean on the East and the Bay of Chesapeake on the West" to the Calvert family. For a while, armed skirmishes between the Virginia and Maryland contingents flared up as the settlers tried to sort out territorial ownership, most notably on the Pocomoke River and Kent Island.

Towns such as Chestertown, Easton, Oxford, Cambridge, Salisbury, and Pocomoke City were established on navigable rivers for protection and transportation as the early colonists set up plantations on which they grew primarily tobacco. That crop was replaced by garden farming in the 19th century, and

that, in turn, has been replaced mostly with grain in support of the substantial chicken "farms" operated by the likes of Perdue and Tyson.

In parallel fashion, fishing industries, with their hardworking watermen, grew on the bountiful catches of fish, crabs, and oysters offered by the bay and its tributary rivers. During the latter part of the 19th century and beginning of the 20th century, wintering wildfowl – geese and ducks – were so plentiful that they were massacred and exported to major cities until their populations became so decimated that hunting regulations were imposed. Today hunting remains an important overlay on the basic agriculture and fishing economies of the Eastern Shore culture.

Old buildings speak to the region's history – churches, houses, fish processing plants, and mills. Many are on the National Register of Historic Places, including some Skipjacks, the traditional oystering sailboats. The Eastern Shore abounds with colorful names of the plantations or houses – Mount Harmon, Castle Hall, Dale's Right, Hayward's Lott, Make Peace, Reward, William's Conquest, Crooked Intention, Bennett's Adventure, Honeysuckle Lodge – the list goes on. Some names sound grand, but their houses are small and humble. Others are quite the opposite.

For most of its history the region was fairly isolated from the flow of land traffic and trade along the east coast. It is a large cul-de-sac that sits to the south of the major travel routes. It was largely accessible only by boat until the Chesapeake Bay Bridge opened it to a new economy: recreational visitors and retirees from Baltimore and Washington, DC.

The history and culture of the Eastern Shore is interesting, but the real story is the Chesapeake Bay and its edges. The bay is an estuary, the largest in the US. The Atlantic Ocean aside, an argument can be made that it is the single most important body of water on the East Coast by virtue of its size and value to fisheries and human recreational activities. Its beautiful and serene marshes are important breeding grounds and nurseries for fish, crabs, and oysters. Approximately 17 million people live in the Chesapeake Bay watershed. The watershed encompasses 64,000 square miles in parts of six states. Including tidal wetlands and islands, the bay has 11,600 miles of tidal shoreline – a distance that would reach almost halfway around the world.

Ironically, we humans, who are attracted to the bay for its beauty, fishing, and recreation, are also unknowingly potential contributors to its destruction. And that does not include all those who live and farm in its watersheds. Once vibrant and busy fishing villages are slowly shrinking, as the catch – the populations of fish, crabs, and oysters – diminishes. This is partly the result of over fishing, but is also because of pollution, nutrients, and sediments that flow from other states and down the watersheds of the many freshwater tributaries – the likes of the Susquehanna and Potomac Rivers – that feed the bay.

Fortunately a number of areas are protected as wildlife refuges, among them the Deal Island Wildlife Management Area, and the Blackwater and Eastern Neck National Wildlife Refuges. The land is so low that in places a trip through the wetlands feels like driving on the water – in some spots that actually happens at high tide. In other places boats seem to be sitting on land. On the outer edges of these areas can be found towns and settlements where watermen live – or used to live.

If one stops to think for a moment – stops taking for granted what the bay has to offer – and realizes that the Eastern Shore's (and indeed Western Shore's) beauty and culture is linked inextricably to the health of the bay, then maybe those who follow us, when looking back on today, will not have to be nostalgic about how it once was.

The images that follow are a sampling of what it is like now with hints of what it once was. They more or less follow a path from north to south, across or past many rivers – the Bohemia, Sassafras, Chester, Choptank, Nanticoke, Wicomico and Pocomoke are just the major ones. While many places of note exist on the farms and towns inland, I have placed emphasis on the coast and rivers and their associated towns and cities – they are what appeal to me most.

There is an old expression: out of sight, out of mind. I hope the viewer of my photographs – and the many wonderful photographs, paintings, and writings done by others – will reflect on them as a collective statement about the unique and beautiful resource the Chesapeake Bay, its edges, and, indeed, the Eastern Shore represent, and that this reflection will, in turn, encourage active husbandry of the region. It deserves it.

CECIL COUNTY

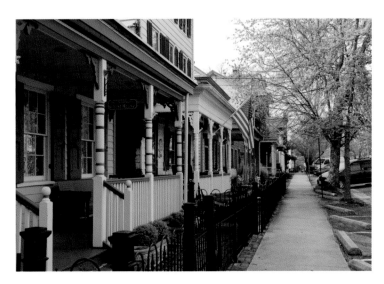

Cecil County, named after Cecilius Calvert, 2nd Baron of Baltimore, is the most northerly county of the Eastern Shore and is bisected by the Chesapeake-Delaware Canal. The Sassafras River forms its southern border.

Chesapeake City is situated on the western end of the Chesapeake-Delaware Canal. It was originally named Bohemia Manor by the Bohemian explorer Augustine Herman and renamed when the canal was constructed in 1839.

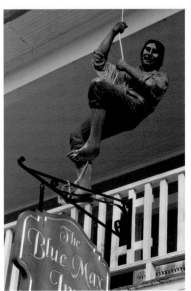

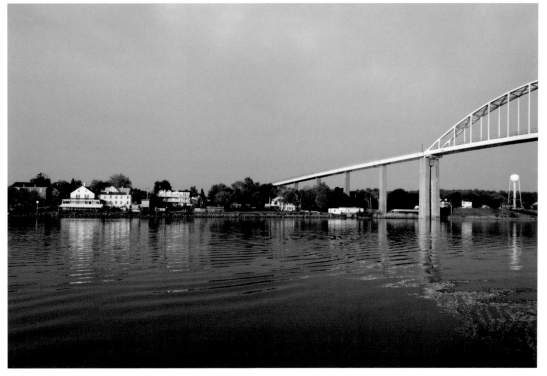

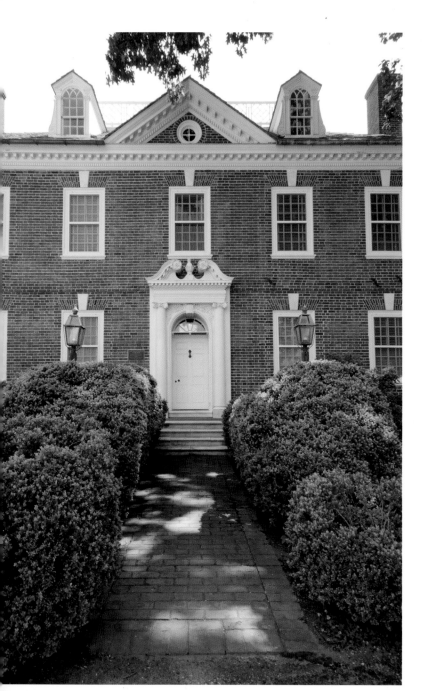

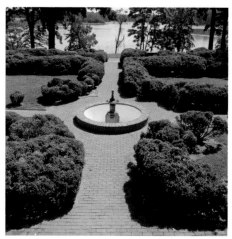

Mt. Harmon Plantation and its Georgian manor house occupy land granted to Godfrey Harmon in 1651; it once flourished as a tobacco plantation. Its gardens overlook the Sassafras River. The house was restored by a member of the duPont family.

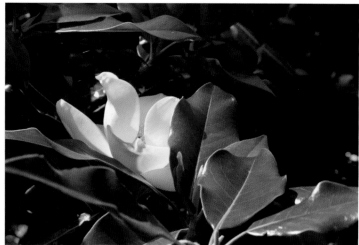

Magnolia flower.

Mount Harmon Plantation

The Bohemia River flows through what was a large plantation granted to Augustine Herman, First Lord of Bohemia Manor, by Cecilius Calvert in the 17th century.

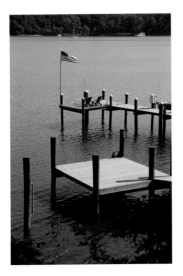

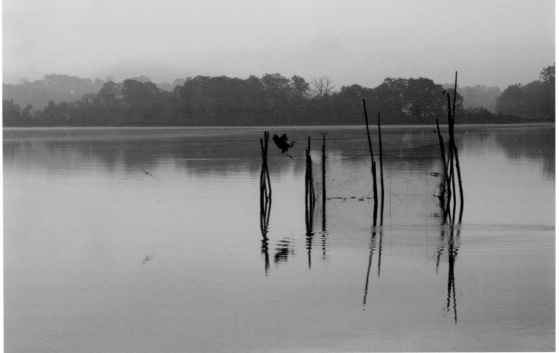

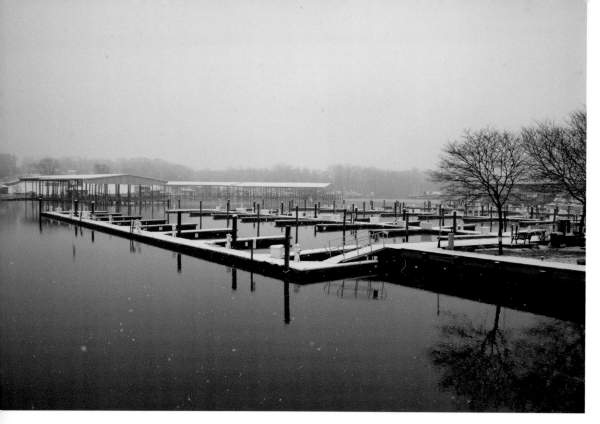

Winter view, from Fredericktown, of empty marinas on the
Sassafras River. It was originally named Tockwough River by Capt.
John Smith after the tribe of Indians that inhabited its banks.

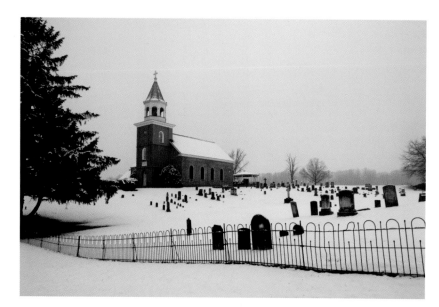

Old Bohemia Church, also known as St. Francis Xavier
Church, was founded by Jesuits in the late 18th century.
It played a critical role in the formation of the American
Catholic Church.

KENT COUNTY

Snow geese flock to the Eastern Shore in ever increasing numbers. They are considered to be a pest by some farmers because they destructively uproot grass and crops.

Kent County was established around 1640 and is bordered by the Sassafras River to the north and the Chester River to the south.

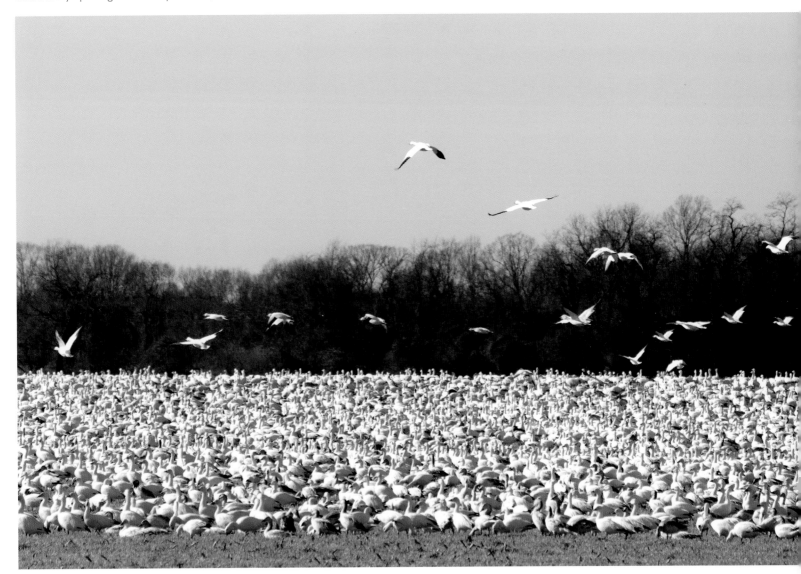

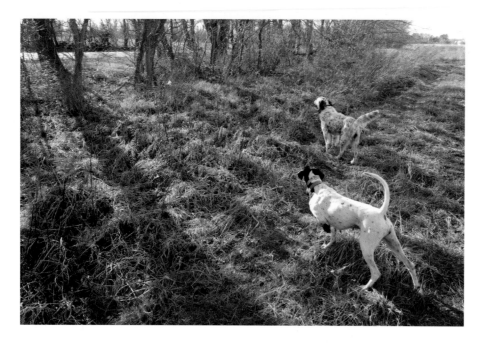

Opposite: A countless number of shooting blinds mark the region's landscape.

Hunting is a major fall and winter sport throughout the region. A pair of pointers on point, and a rare shot of a quail on the wing.

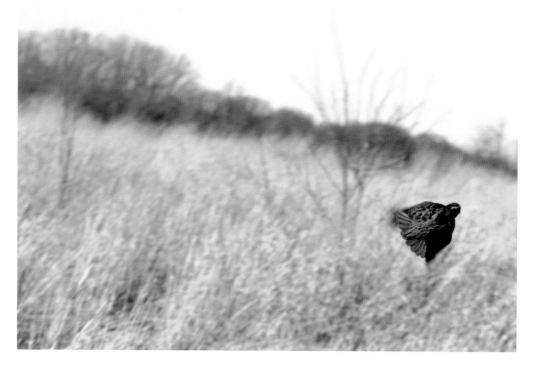

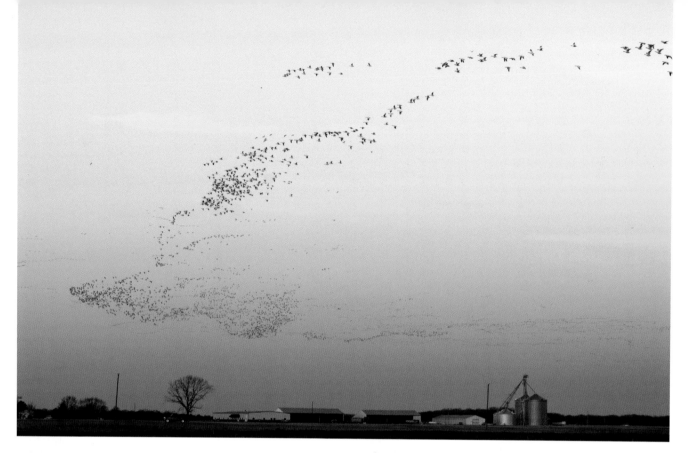

Snow geese on the move.

Shrewsbury Chapel in Kennedyville is the burial place of General John Cadwalader, a Philadelphian and the commander of Pennsylvania troops during the Revolutionary War.

Chestertown was founded in 1706 and is one of the oldest ports on the Eastern Shore. Its founders chose a spot several miles up the Chester River, well-protected from invaders.

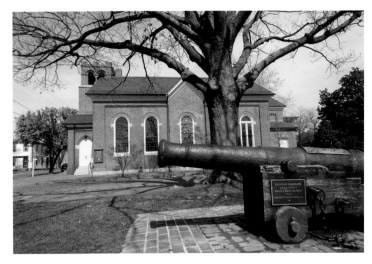

Emmanuel Church was constructed in 1767 in what was then a parish of the Anglican Church. Notably, it was here, in 1780, that the clergy decided to rename the Church of England in budding America as the Protestant Episcopal Church.

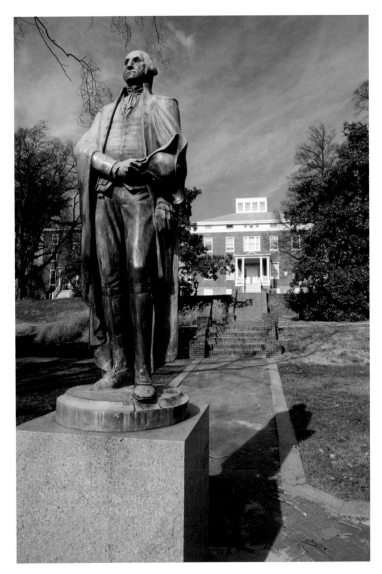

Washington College was founded in 1782 at the behest and patronage of George Washington. It evolved from the Kent County School to become the 10th oldest college in the country.

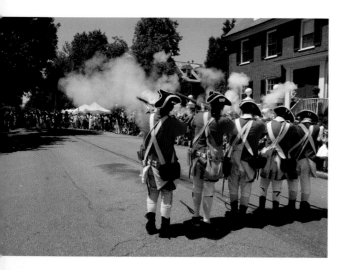

Every year, in the Spring, Chestertown celebrates its version of the Boston Tea Party.

Chestertown is home to the Schooner Sultana, a replica of a Boston-built merchant vessel that served for four years in the British Royal Navy.

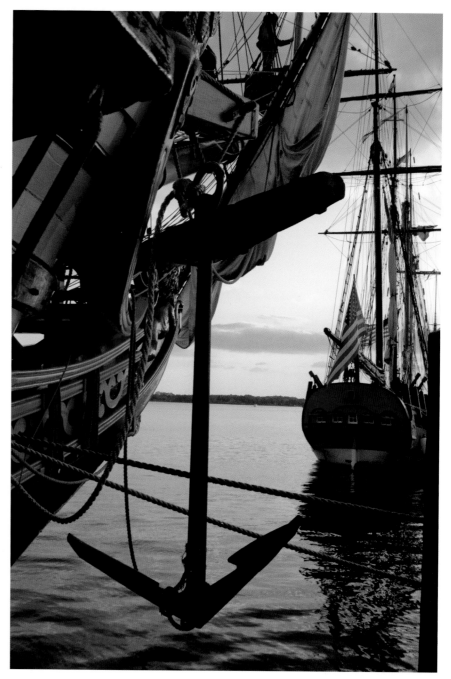

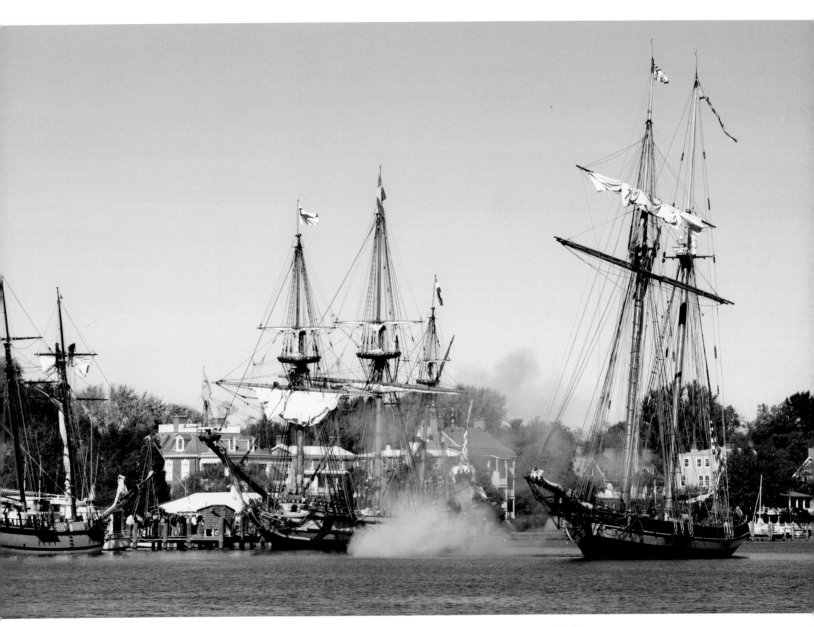

The Pride of Baltimore and the Kalmar Nickel duke it out during downrigging weekend in Chestertown.

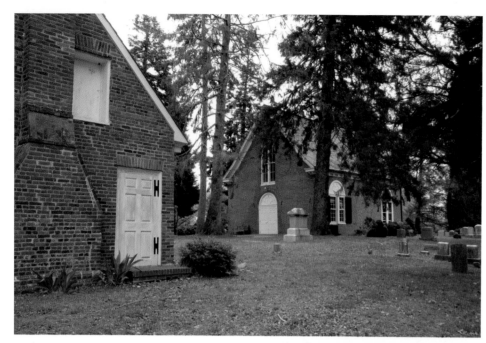

St. Paul's Church, Fairlee is the second oldest existing Episcopal Church building on the Eastern Shore. Tallulah Bankhead is buried here.

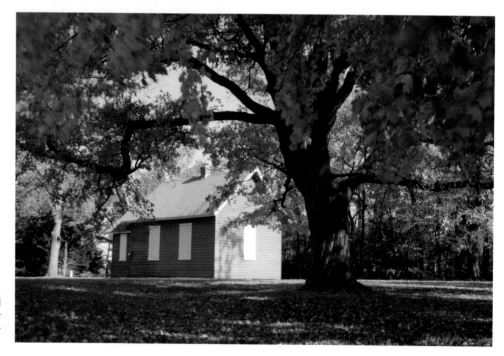

Cliff's Schoolhouse, outside of Chestertown, was built in 1878 to serve the watermen and farmers in the area. Unlike today, one teacher was responsible for seven grades and as many as 46 students at time.

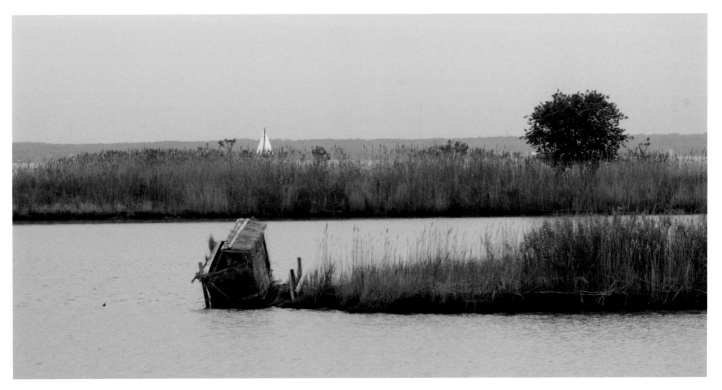

The Eastern Neck National Wildlife Refuge is part of the Chesapeake Marshlands National Wildlife. The island on a bend of the Chester River was one of the first places settled on the Eastern Shore.

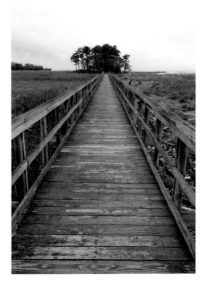

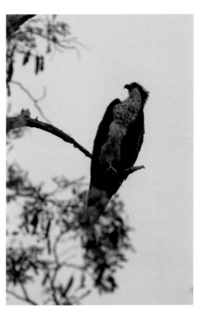

Osprey.

Chicken farms are plentiful throughout the Delmarva Peninsula. This one happens to be in Dorchester County.

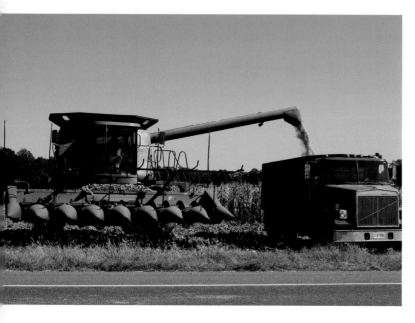

Inland from the bay, agriculture is an important part of the economic life of the Eastern Shore.

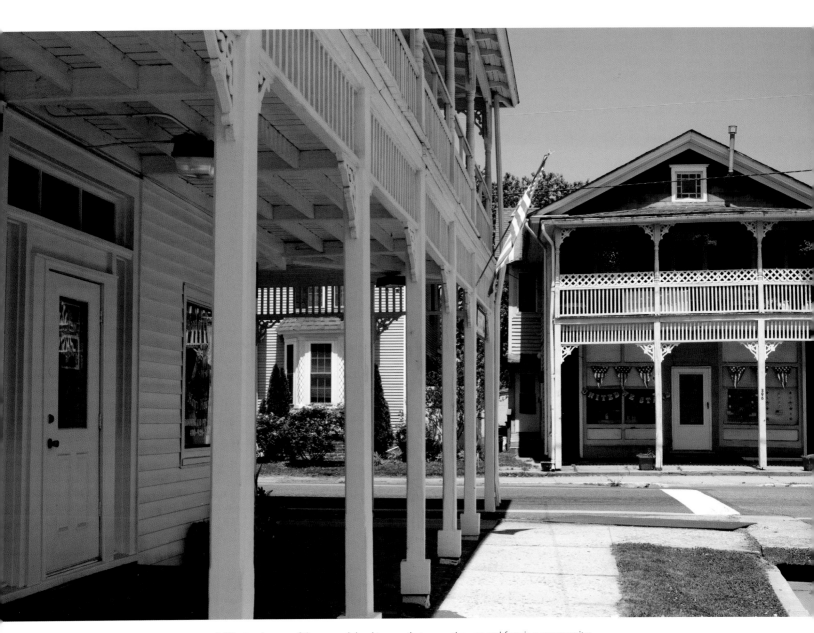

Millington is one of the many inland towns that serve the general farming community.

QUEEN ANNE'S COUNTY

Established in 1706, the county is named for Queen Anne, who reigned over England at the time. The Chester River forms its northern boundary and Talbot County lies to its south.

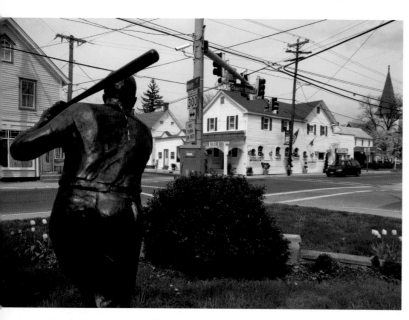

Another farming town, Sudlersville, was home to the famous baseball slugger, Jimmie Foxx.

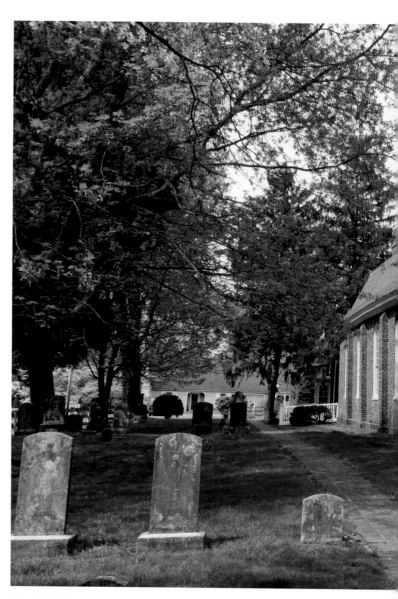

Church Hill. St. Luke's Episcopal Church (1732) is one of the oldest intact brick churches in the region. Its bricks were made in England and paid for by 140,000 pounds of tobacco grown in the area.

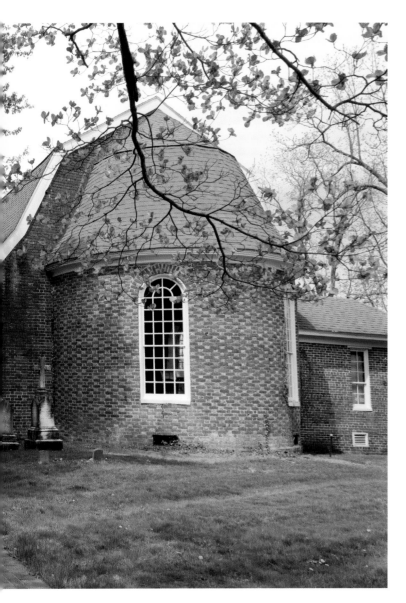

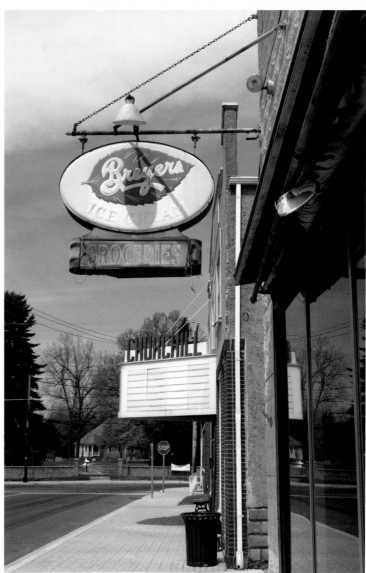

The Church Hill movie theater was renovated to become a performing arts center for the local area.

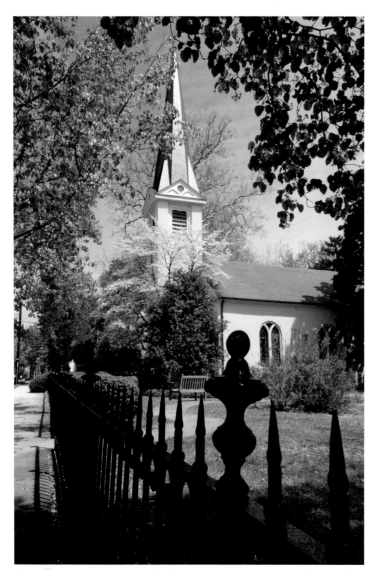

Centreville, located on the Corsica River, uses the French spelling "Centre Ville" in recognition of the role the French played in the American Revolution.

Kent Island is the largest island in the Chesapeake Bay and sits at the bay's narrowest point between the eastern and western shores, directly across from Annapolis. During early colonial times it was the site of territorial skirmishes between the Virginia colony and the Calverts.

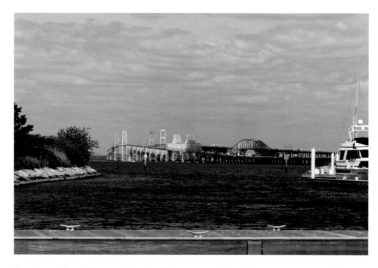

As viewed from Stevensville, the Chesapeake Bay Bridge was completed in 1952 and opened the region and beaches along the Atlantic Ocean to visitors from Annapolis and Washington, D.C.

The Romancoke fishing pier is on a site used as a ferry landing prior to the construction of the Bay Bridge.

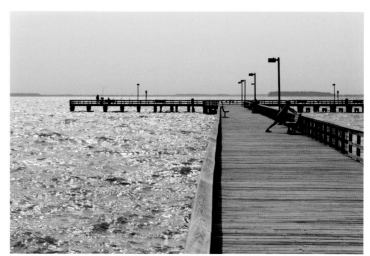

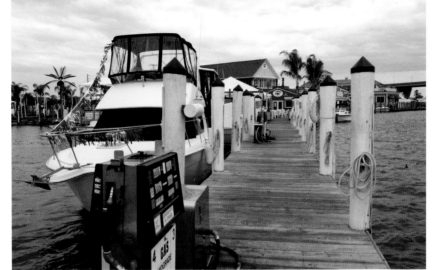

Boating and other recreational life abound at the marinas along and near Kent Narrows and Kent Island.

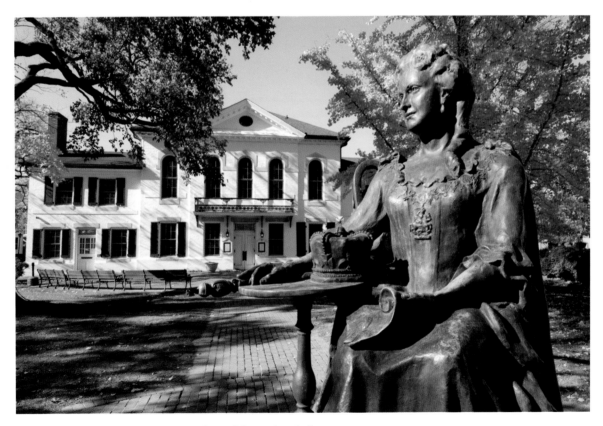

A statue of Queen Anne of England sits in front of Queen Anne's County courthouse in Centreville, the oldest in continuous use in Maryland.

CAROLINE COUNTY

Named for Lady Caroline Eden, the wife of Maryland's last colonial governor, Robert Eden, Caroline County was created in 1773 from parts of Dorchester and Queen Anne's counties. The county sits inland and is comprised primarily of farmland. Access to the bay is via the Choptank River, the longest river on the Delmarva Peninsula.

Denton is the seat of Caroline County and its courthouse was built in 1797. The town sits next to the Choptank River on land once known as Pig Point.

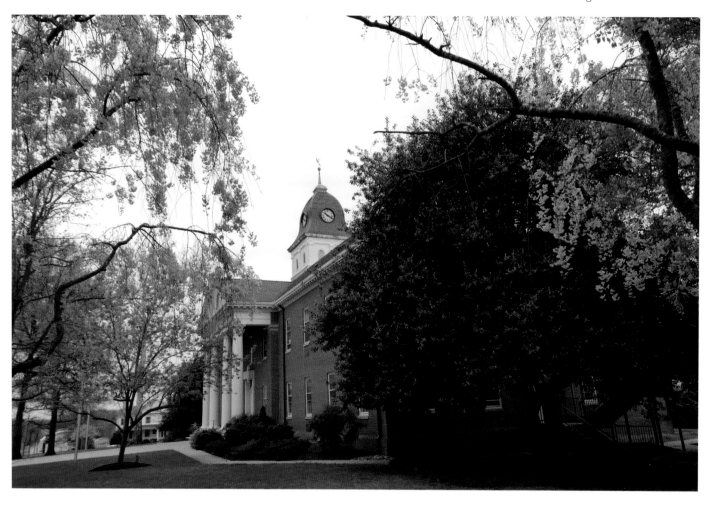

An age-old past time – fishing in the Choptank River.

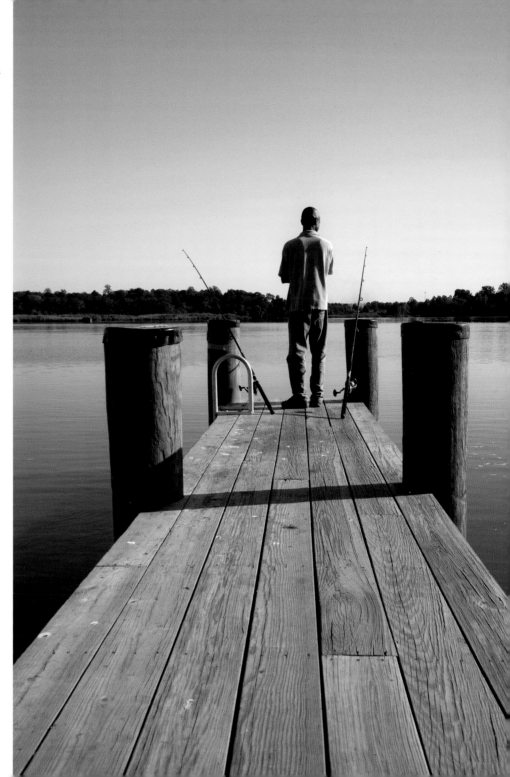

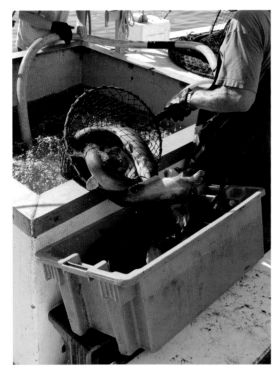

Catfish to be trucked to New York are unloaded from a boat in Choptank. The town was named after the river and the Native American tribe that had a settlement here before 1679.

TALBOT COUNTY

Talbot County was established in the mid-1660s and was named for Lady Grace Talbot, sister of Cecilius Calvert and the wife of Sir Robert Talbot, an Irish statesman. The eastern branch of the Wye River is part of its northern boundary, and the Choptank River bounds it to the south.

The Wye Mill is located in Wye Mills and is one of the earliest industrial sites on the Eastern Shore in continuous use. The historic grist mill's waterwheel still powers late 19th century equipment.

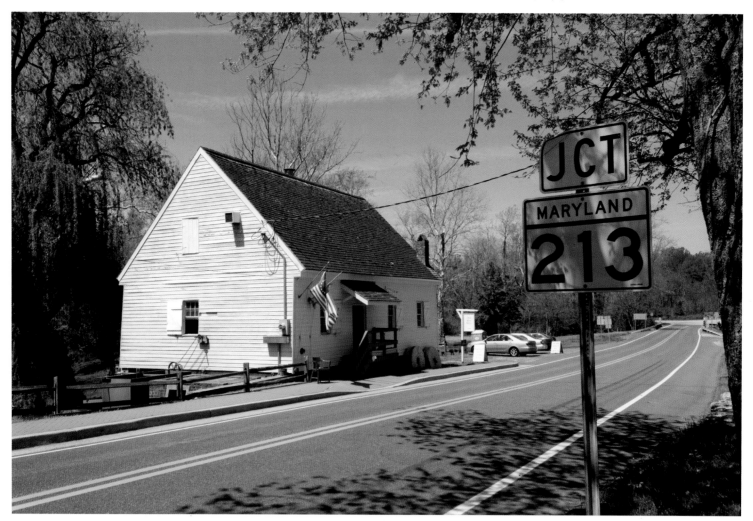

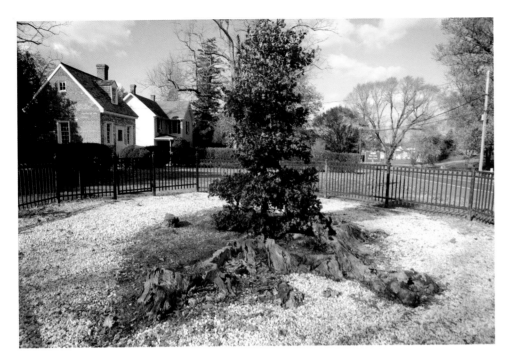

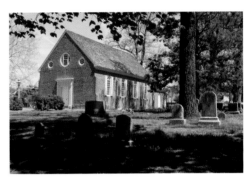

Old Wye Episcopal Church.

A clone of the famous Wye Oak grows from the stump of the once largest white oak in the US. The original was believed to have been 460 years old when it was destroyed during a storm in 2002.

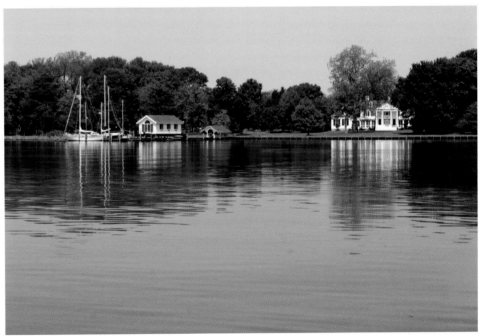

A view across the Miles River between St. Michaels and Easton.

The Chesapeake Maritime Museum was established in 1965 and sits on the site of fish processing houses in St. Michaels. It is home to a number of vessels that have historic ties to the Chesapeake.

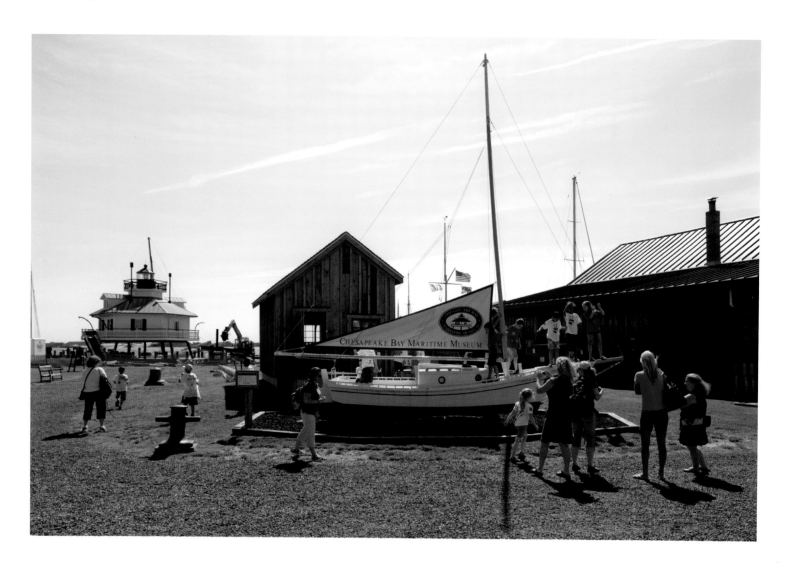

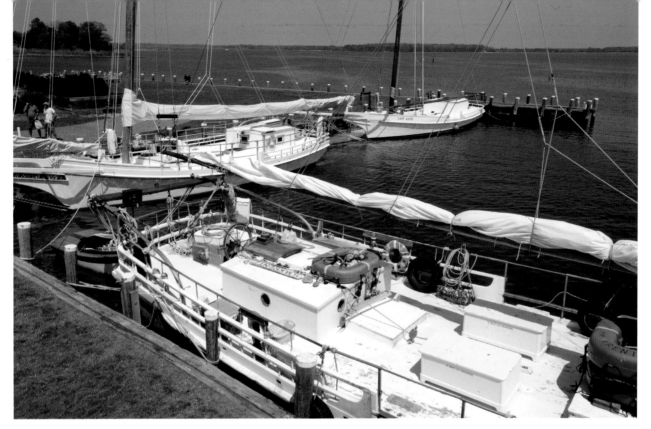

Skipjacks were built for power specifically to dredge for oysters in the Chesapeake Bay.

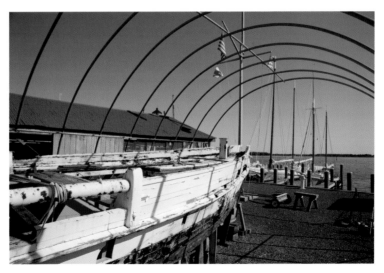

Skipjack under restoration at the museum.

Early on Saint Michaels was a shipbuilding town that notably produced fast schooners known as Baltimore clippers. It gets its name from an early Anglican chapel that was established there. Frederick Douglass was born and lived as a slave near here until he escaped north and became a famous abolitionist orator.

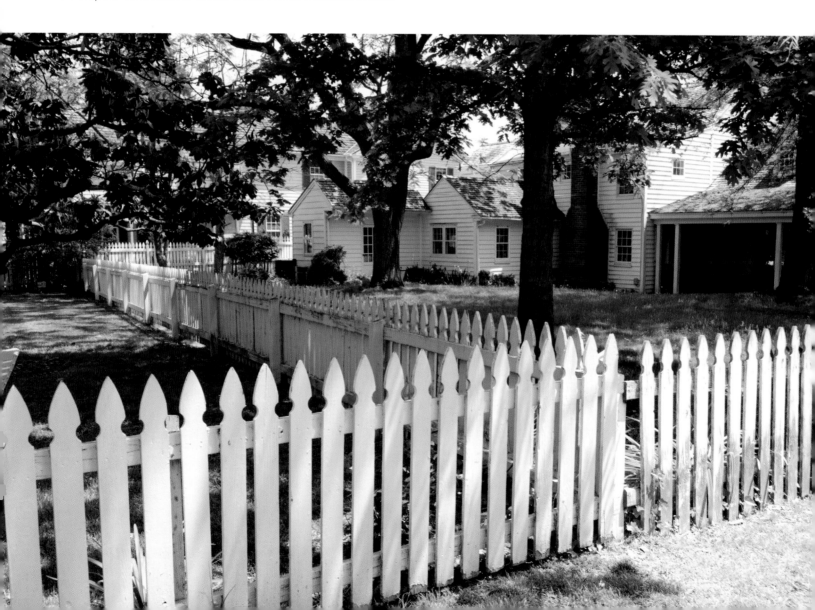

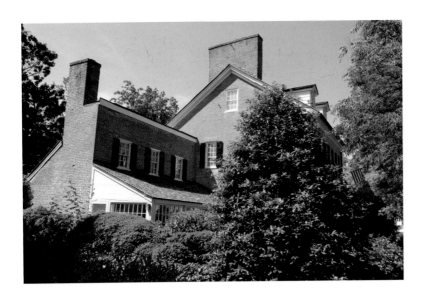

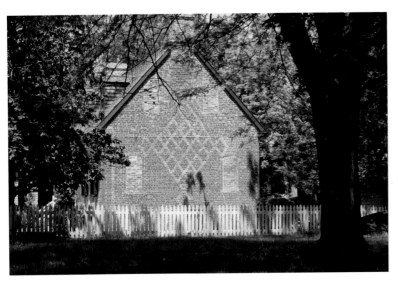

Tilghman Island was originally known as Great Choptank Island but eventually took on the name of its owners. It became a center for oystering as well as a get away spot for summer vacationers. The British invasion fleet occupied the island in 1814 in order to acquire provision.

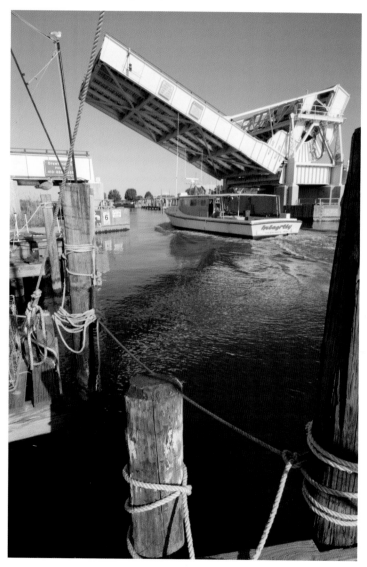

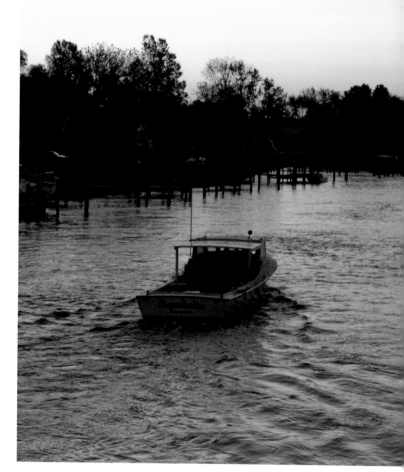

Knapps Narrows separates Tilghman Island from the mainland and is a busy thoroughfare for commercial and recreational boats. The drawbridge across it seemingly never rests.

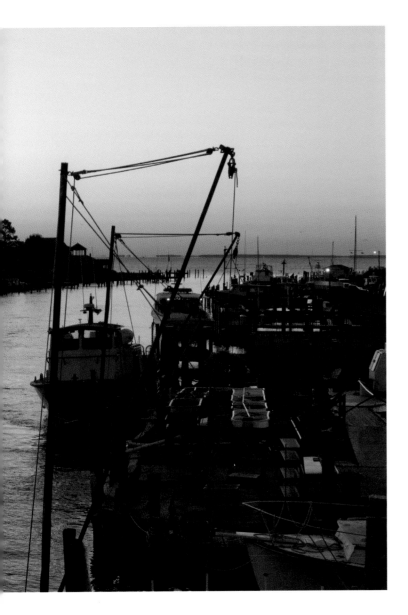

Fishing boats, Tilghman Island.

Recreational and commercial fishing boats, Tilghman Island.

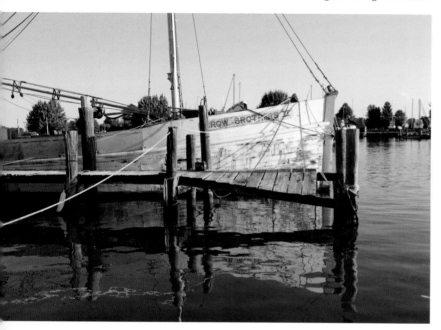

Opposite: St. John's Chapel, Tilghman Island.

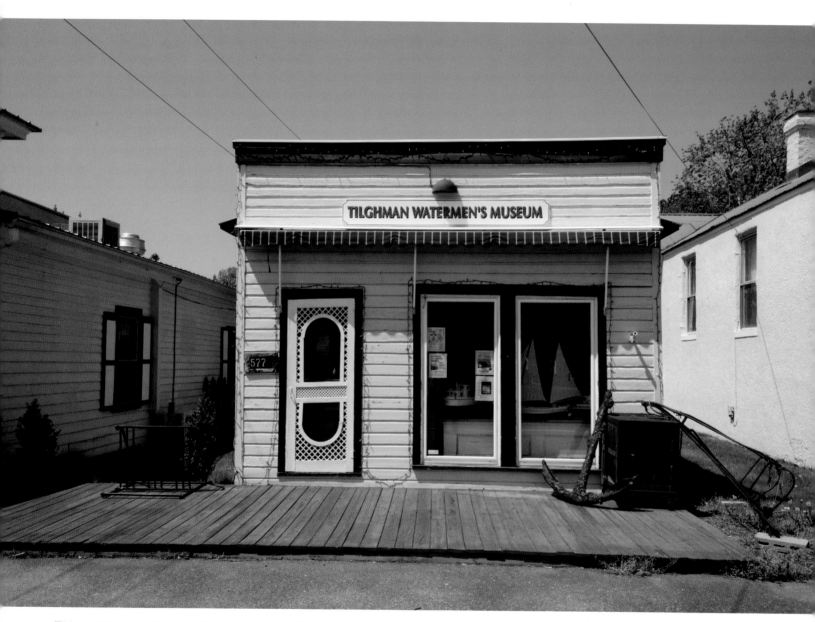

Tilghman Watermen's Museum. The watermen of the Chesapeake are legendary.

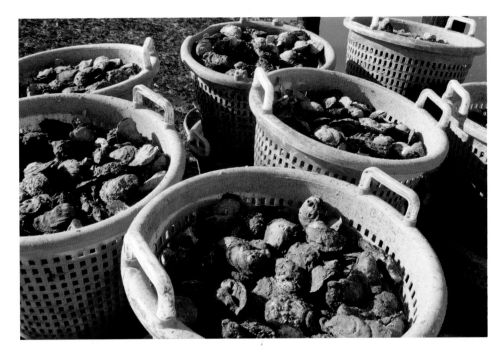

The traditional catch of watermen – oysters and blue crabs.

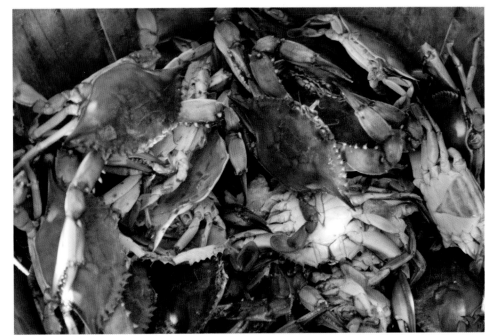

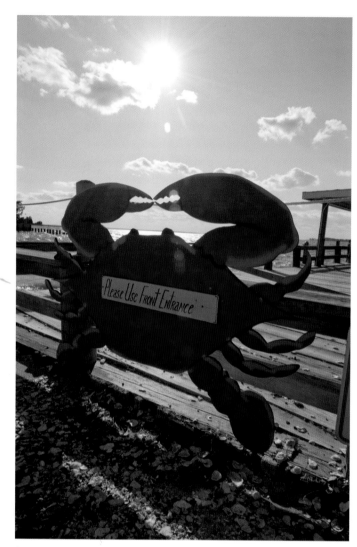

A pervasive symbol on the Eastern Shore.

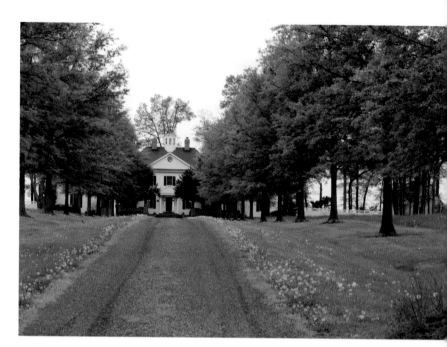

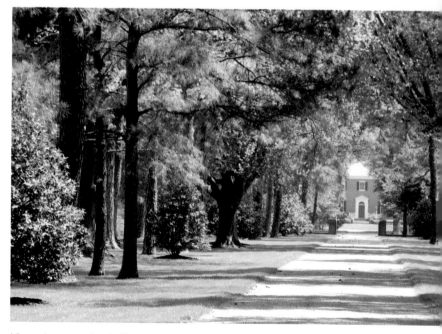

Views down tree-lined *allées* to a house are a common sight throughout the region.

Oxford is on the Tred Avon River and was originally named Third Haven. Prior to the American Revolution the town was one of only two official ports of entry in Maryland and enjoyed international prominence as a shipping port for surrounding tobacco plantations.

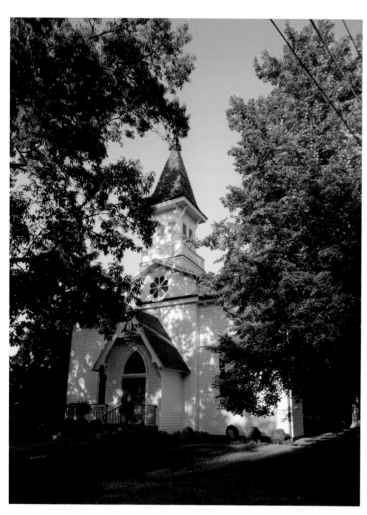

Church of the Holy Trinity, Oxford.

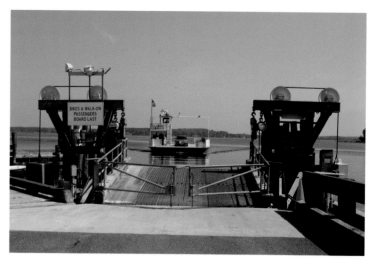

Oxford-Bellevue ferry.

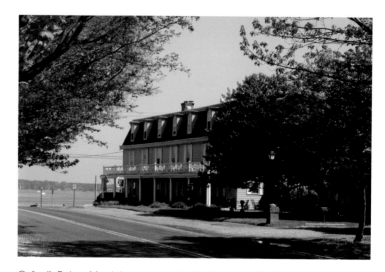

Oxford's Robert Morris Inn was once the family home of the famous financier of the American Revolution. It overlooks the Tred Avon River and the Oxford-Bellevue Ferry, which is believed to be the oldest privately operated ferry in the US.

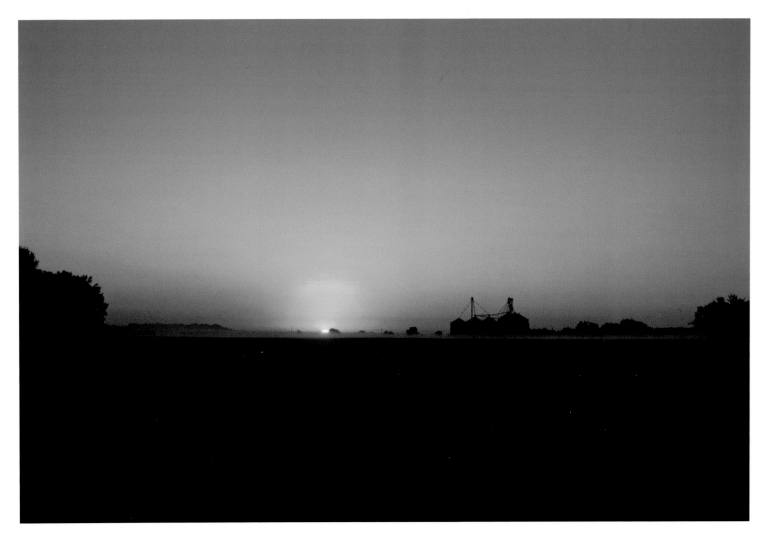

Near Oxford.

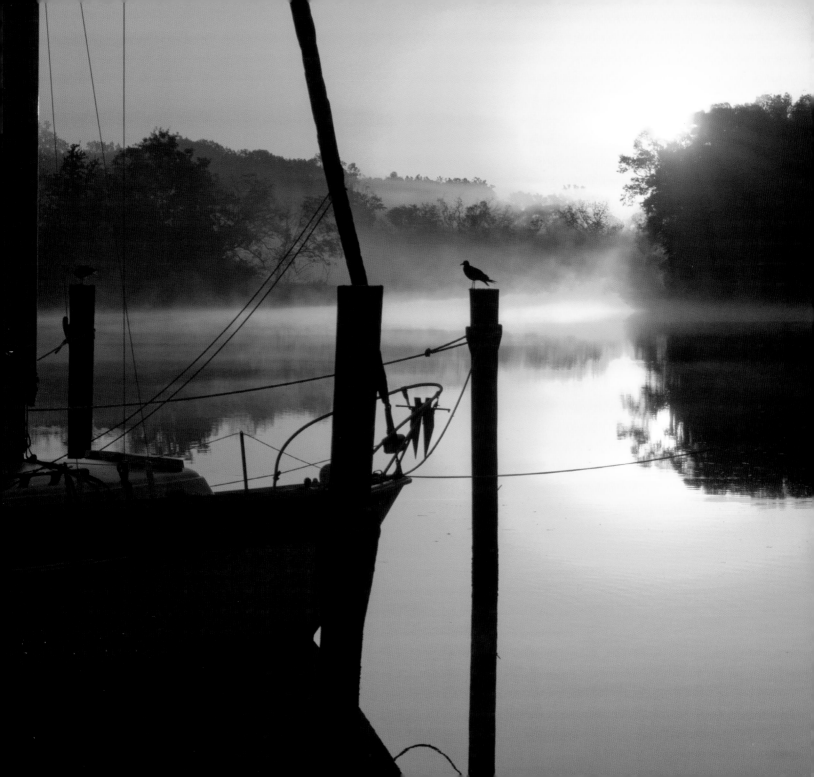

La Trappe Creek.

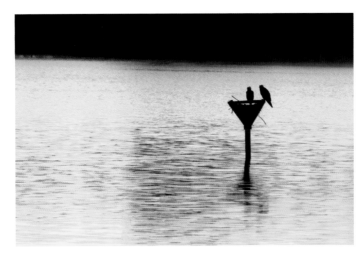

A familiar sight of nesting ospreys.

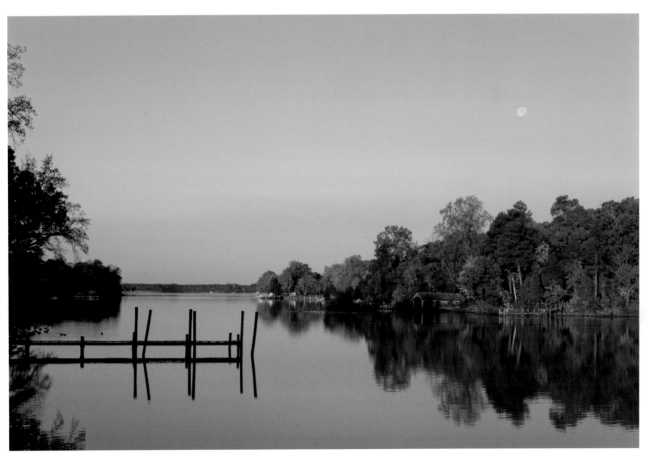

Tred Avon River outside of Easton.

45

Easton was established in 1710 and is the seat for Talbot County.

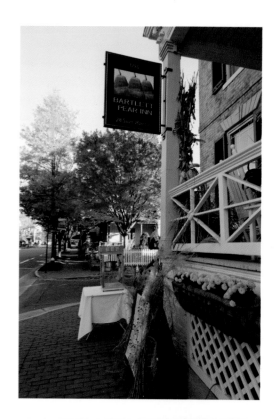

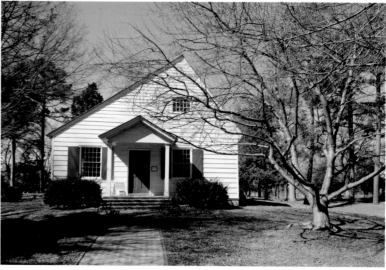

The Third Haven Meeting House in Easton dates back to the late 1650s and is the oldest Quaker meeting and one of the oldest places of worship in Maryland.

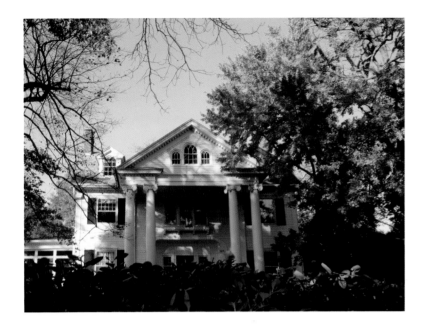

Wildfowl carving has become a recognized art form and many people display their magnificent work at the festival.

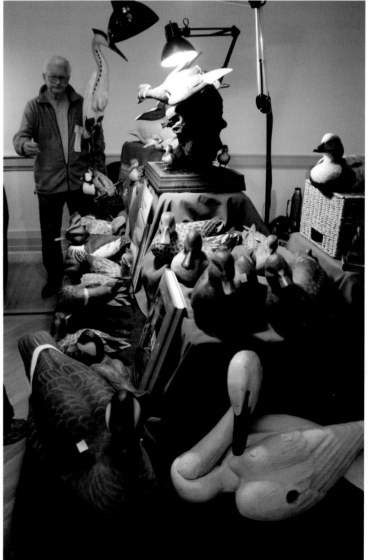

Every fall the town is host to an important Waterfowl Festival that attracts exhibitors from all over the country.

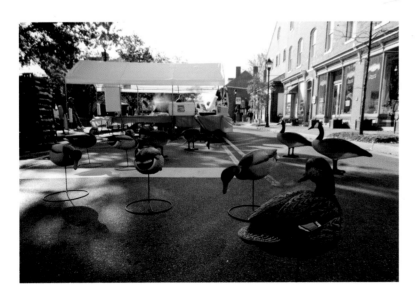

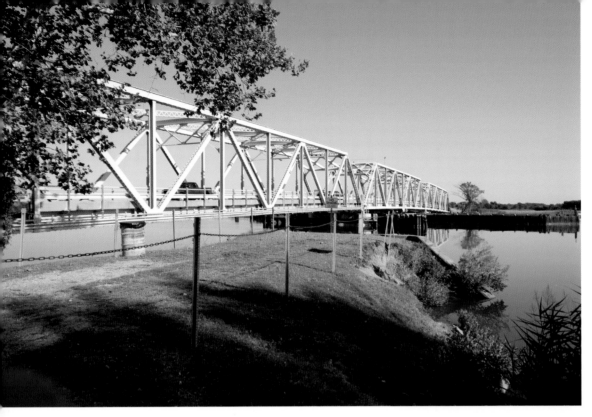

Rt.331 Bridge across the Choptank River into Caroline County.

Chesapeake Bay retrievers hark back to the 19th century when a pair of St. John's Water Dogs from England were rescued from a shipwreck and bred with local dogs to make a new durable hunting breed.

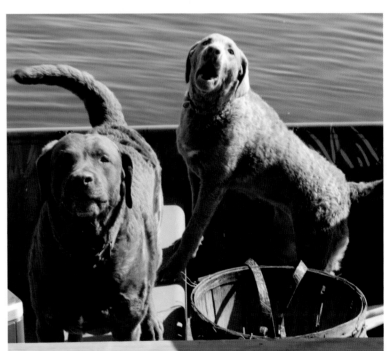

DORCHESTER COUNTY

Dorchester County lies across the Choptank River from Talbot County. It is named for the Earl of Dorset, a family friend of the Calverts. The Nanticoke River forms its southern boundary. Situated on the Choptank River, Cambridge was settled by English colonists and dates back to 1684. It occupies part of the former Choptank Indian Reservation. As was the case with many other port towns, it was a trading center first for tobacco and then for produce grown on surrounding plantations. It was also home to seafood processing plants.

Choptank River, the longest on the Eastern Shore.

Skipjack Nathan at her berth.

Farmer's Market, Cambridge.

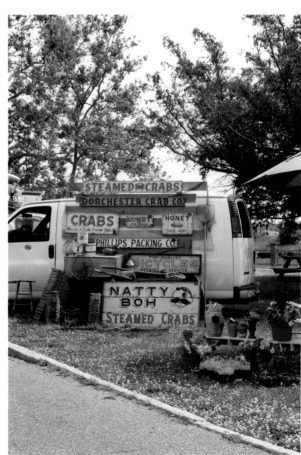

High Street, Cambridge

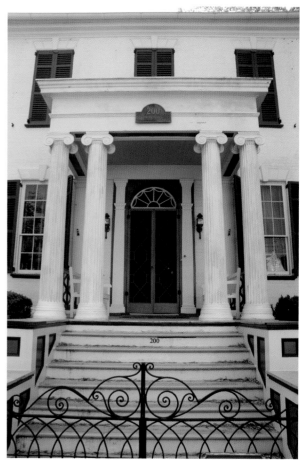

Goldsborough House, Cambridge. The Goldsboroughs were a prominent family on the Eastern Shore.

Race Street, Cambridge.

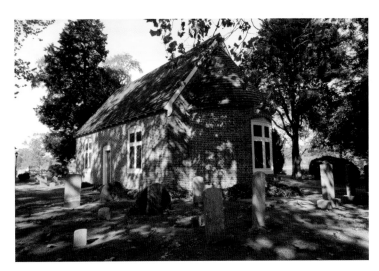

Old Trinity Church (1692), in Church Creek, is the oldest Episcopal Church building in Maryland.

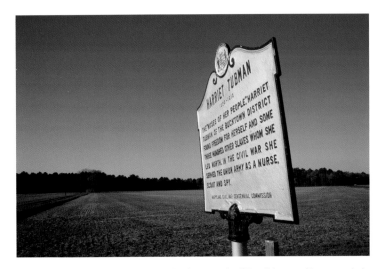

The historical marker overlooking this farm reads, "The 'Moses of her people,' Harriet Tubman found freedom for herself and some three hundred other slaves whom she led north.'" Bucktown area outside of Cambridge.

Chapel of Ease, Old Trinity Church. Taylor's Island.

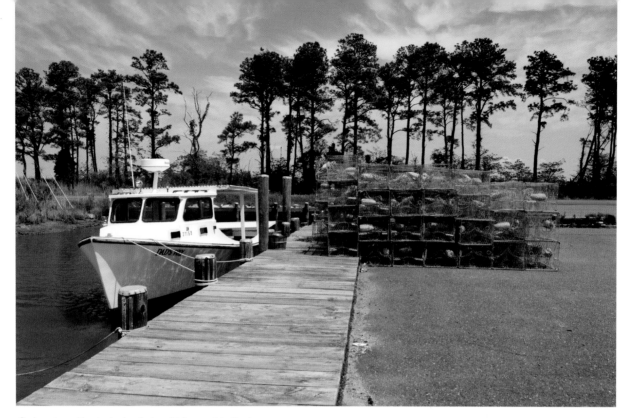

Crab pots waiting to be loaded and taken out to the bay.

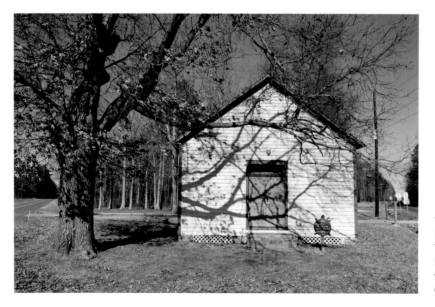

The Nause-Waiwash Band of Indians Longhouse – 1899. The name refers to two Nanticoke Indian ancestral villages. Bucktown area outside of Cambridge.

The Blackwater National Wildlife Refuge is one of the great gems of the Eastern Shore. Its expansive marshes and waterways are home to countless species of both resident and migratory wildlife. Small watermen's villages mark the outer edges of the refuge.

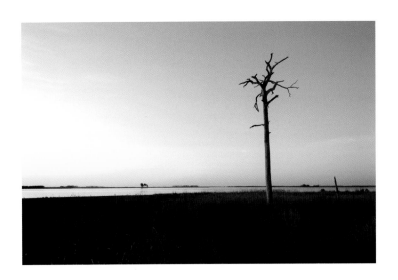

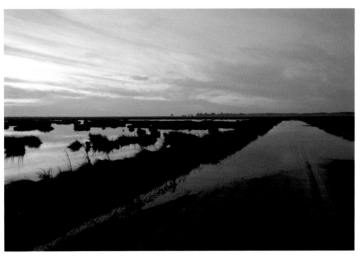

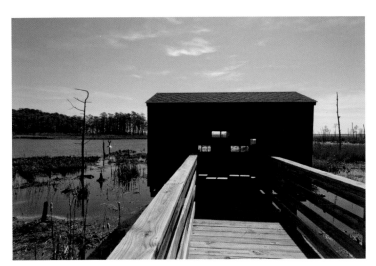

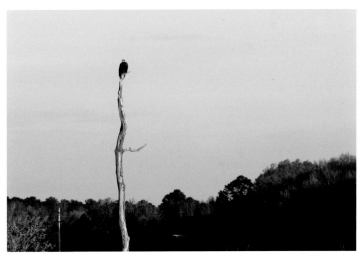

Bald eagle.

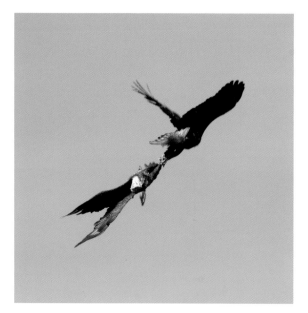

Two bald eagles in a tussle.

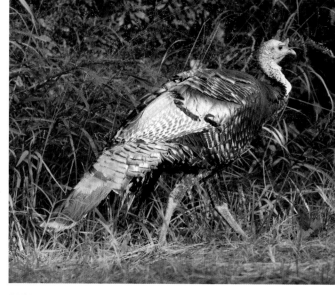

Wild turkey.

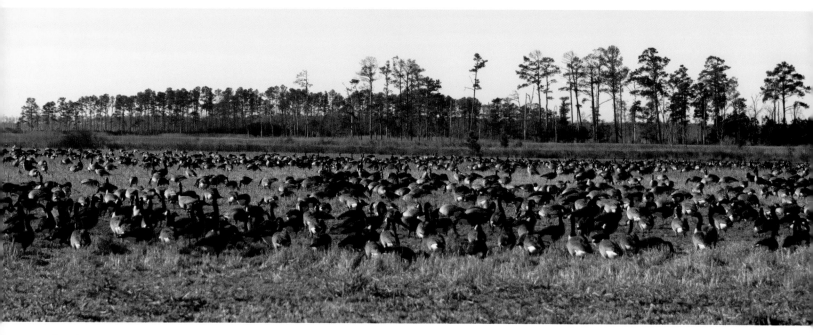

Canada geese.

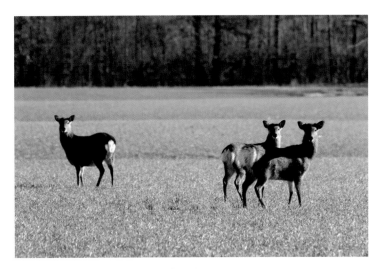

Sika deer were originally imported from Japan.

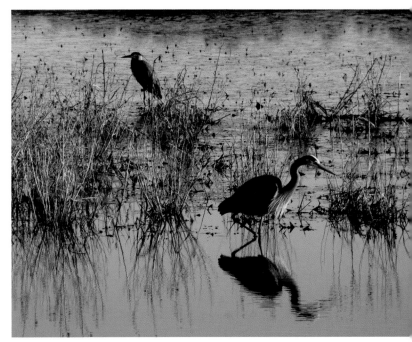

Great blue herons and shoveler ducks.

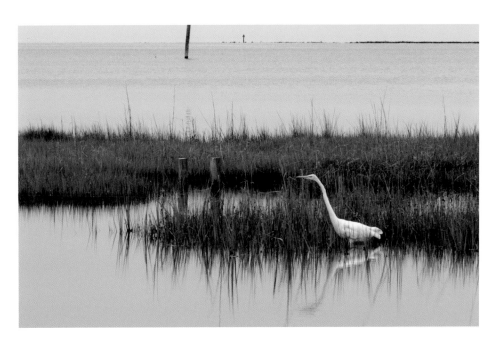

White heron, Smith Island.

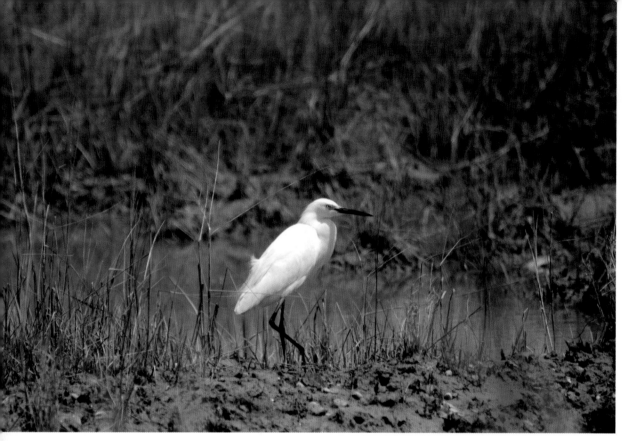

Snowy egret.

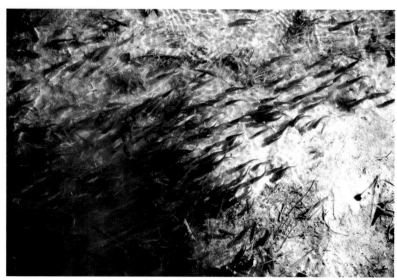

A school of young fish in the "estuarian nursery."

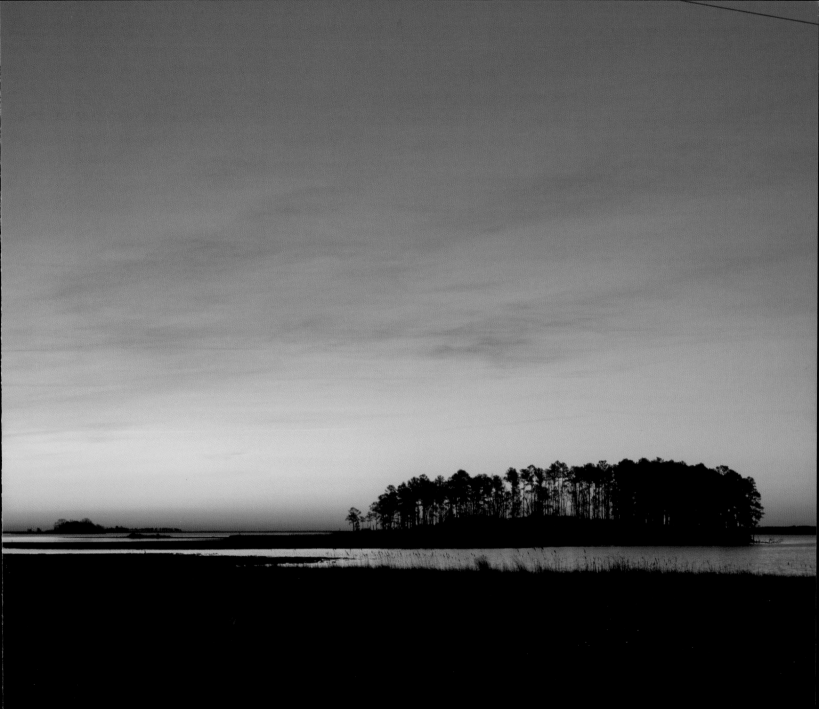

Hooper's Island is considered the oldest settled place in Dorchester County and was named after Henry Hooper, a good friend of the Calverts. Legend has it that the island was bought from the Yaocomaco People for five woolen blankets.

Hooper's Island in the distance.

Fishing Creek near Hooper's Island.

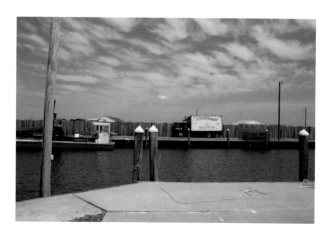

Hooper's Island.

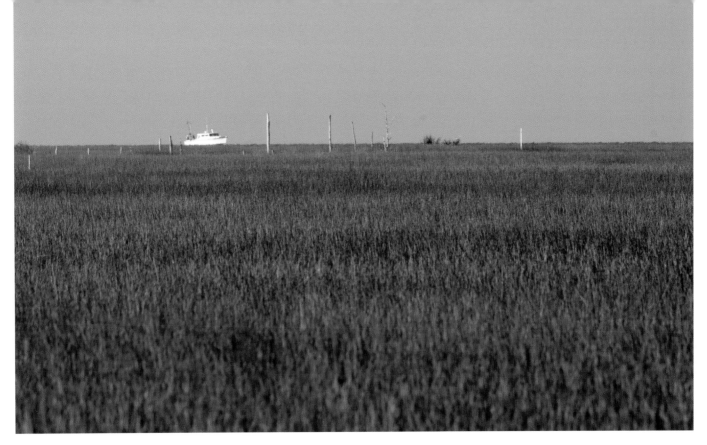

Bishop's Head.

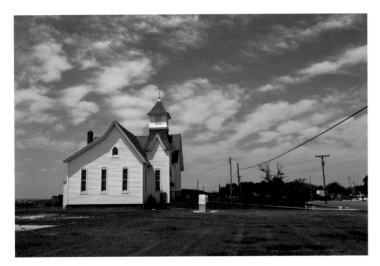

Hooper's Island.

Wingate.

Elliott Island.

A reminder of the Nanticoke, the
original inhabitants, Vienna.

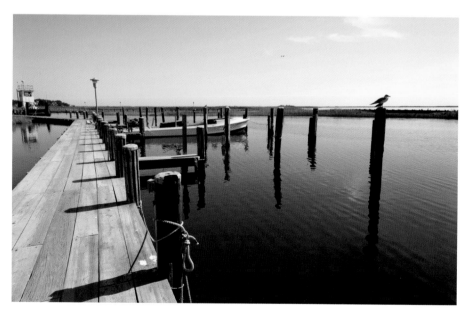

Elliott Island.

WICOMICO COUNTY

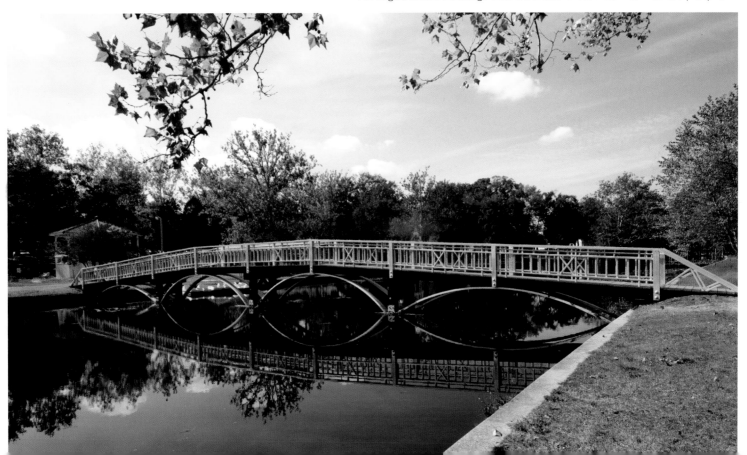

Wicomico County was created in 1867 from parts of Somerset and Worcester counties. It was named for the Wicomico River. The name derives from Algonquian words wicko mekee, meaning "a place where houses are built," apparently referring to an Indian town on the banks.

Salisbury is the largest city on the Eastern Shore region and is the seat of Wicomico County. It sits at the head of the Wicomico River and functions as the transportation hub of the area.

An old Coast Guard buoy tender makes its way up the Wicomico to be scrapped in Salisbury.

An elegant arched footbridge crosses a branch of the Wicomico in Salisbury City Park.

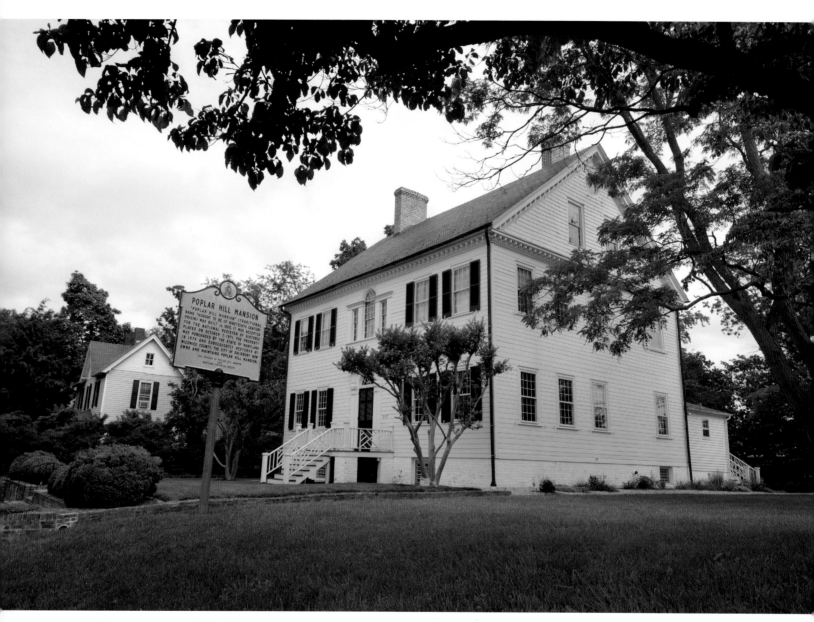

Poplar Hill Mansion was built in 1795, Salisbury.

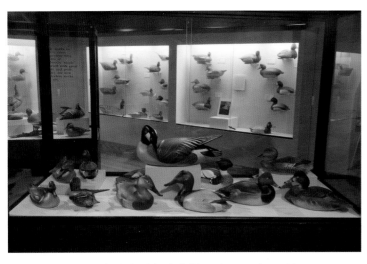

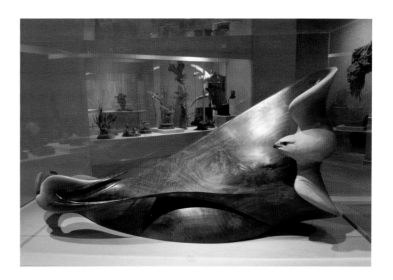

The Ward Museum of Wildfowl Art in Salisbury has a truly world-class collection of old and contemporary shooting decoys and wildfowl woodcarvings.

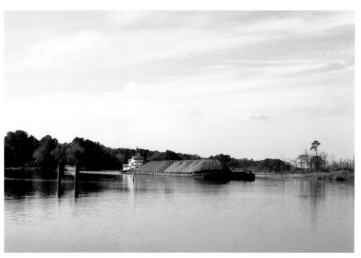

The Wicomico River continues to be used for commercial transportation.

Across the Wicomico the village of Whitehaven sits on a land grant originally called Nobel Quarter. A ferry has crossed the Wicomico River here for about 300 years.

SOMERSET COUNTY

Somerset County was created in 1666 and is named for Mary, Lady of Somerset, wife of Sir John Somerset and Cecilius Calvert's sister-in-law. The county is served by the Wicomico, Annemesex, and the Pocomoke rivers.

Princess Anne is the seat for Somerset County. It sits at the head of the Manokin River and was an important market center because of river, and later railroad, transportation.

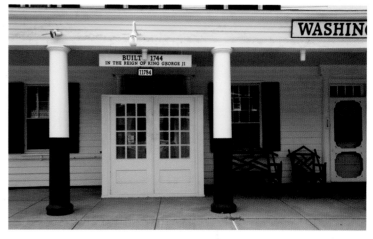

The Teackle Mansion in Princess Anne dates back to the early 19th century and bespeaks some of the wealth that was generated in and around the town.

The Washington Hotel in Princess Anne has been around for a good while, according to the sign over the door.

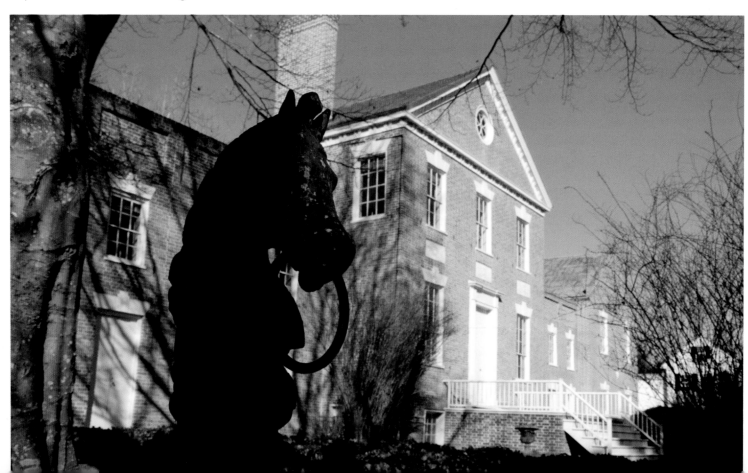

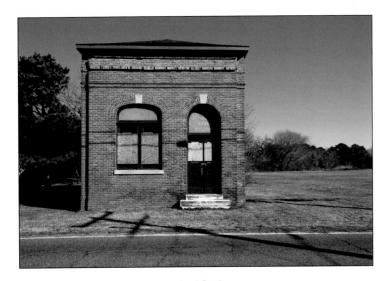

Deal Island is another wild life refuge and was originally named Devil's Island, supposedly because it was a favorite haunt of pirates. The island is home to some fishing villages as well as annual skipjack races.

Tiny, vacated banks like The Deal Island Bank are a common sight throughout the region.

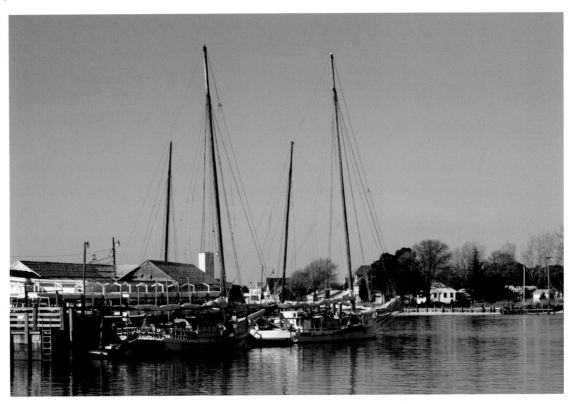

Skipjacks, Deal Island.

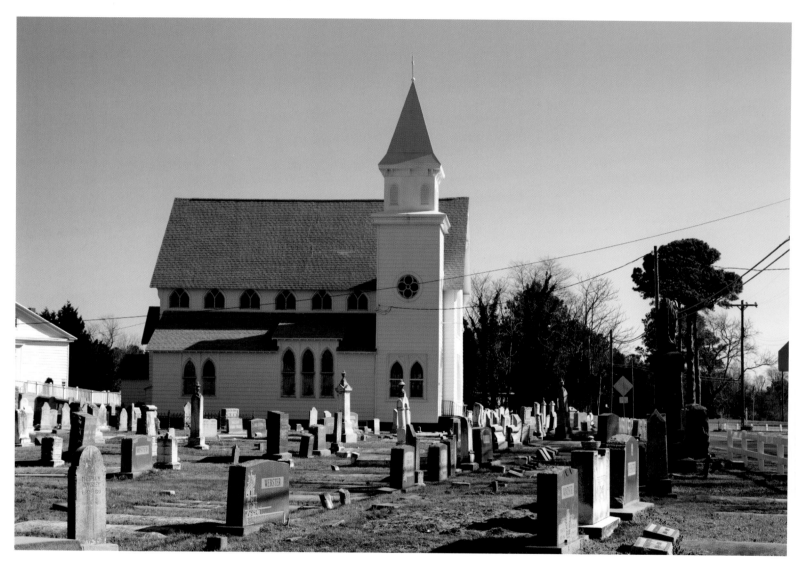

St John's Methodist Church, Deal Island.

One way to keep the rain out of the engine.

A skipjack's oyster dredging license.

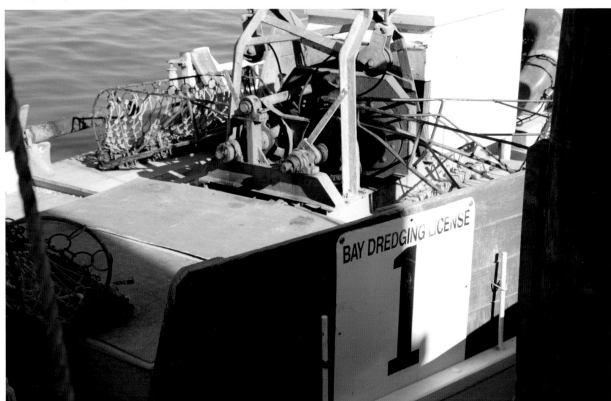

BAY DREDGING LICENSE
1

A small pile of oyster shells, Deal Island.

In the distance, Rumbley is a typical small waterman's harbor on the edge of the wetlands.

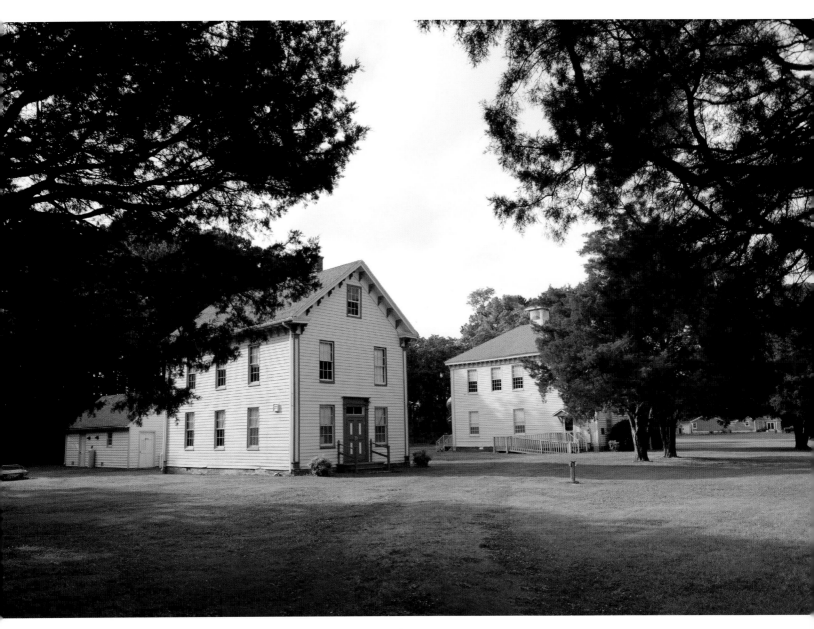

Now closed Fairmount Academy in Upper Fairmount was constructed around the Civil War to serve the population of the Potato Neck District.

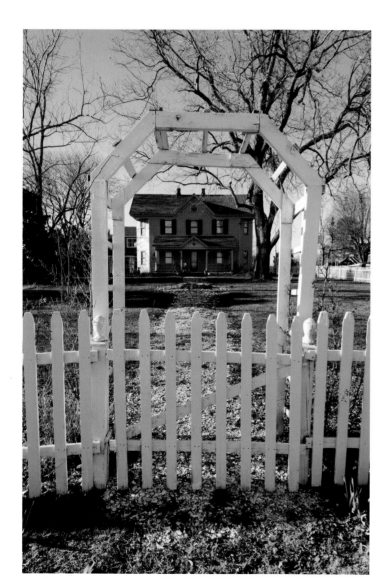

Rumbley harbor and a house along the edge of it with an oyster shell path.

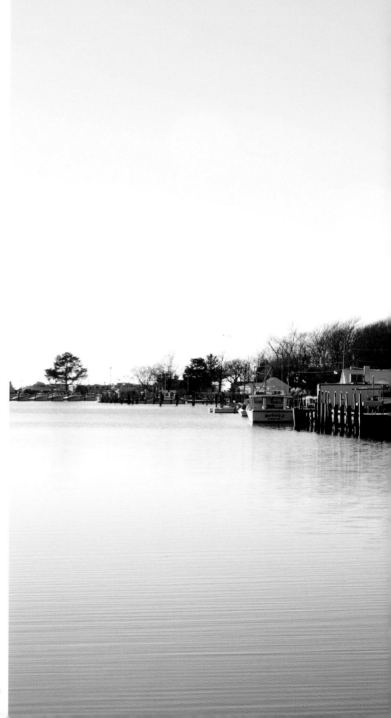

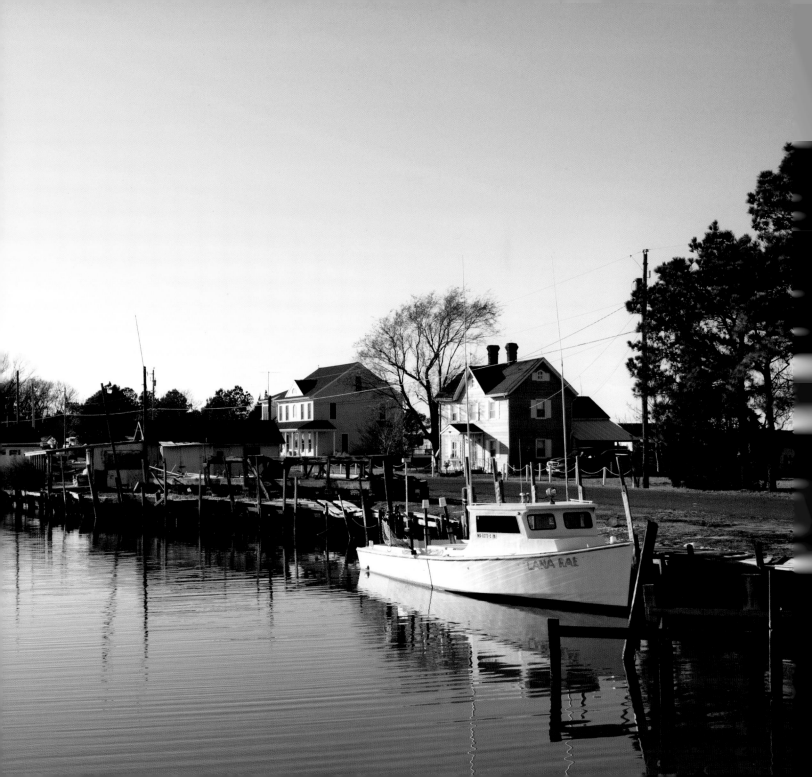

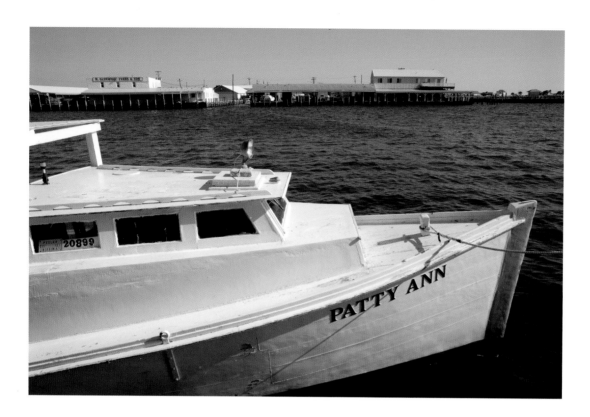

Crisfield was originally known as Annemessex Neck when it was a small fishing village. Over time it grew to be a major seafood center. For a while it was the second most populous city in Maryland and was known as the "Seafood Capital of the World."

Smith Island, which was purchased by Henry Smith and settled in 1657, lies in the bay, several miles out from Crisfield. It is the next to last island of a group that extends south from Cocheron and Stradding Point. In another time, this place and its companion islands might have been the Venice of the Chesapeake. It is that flat and low to the water.

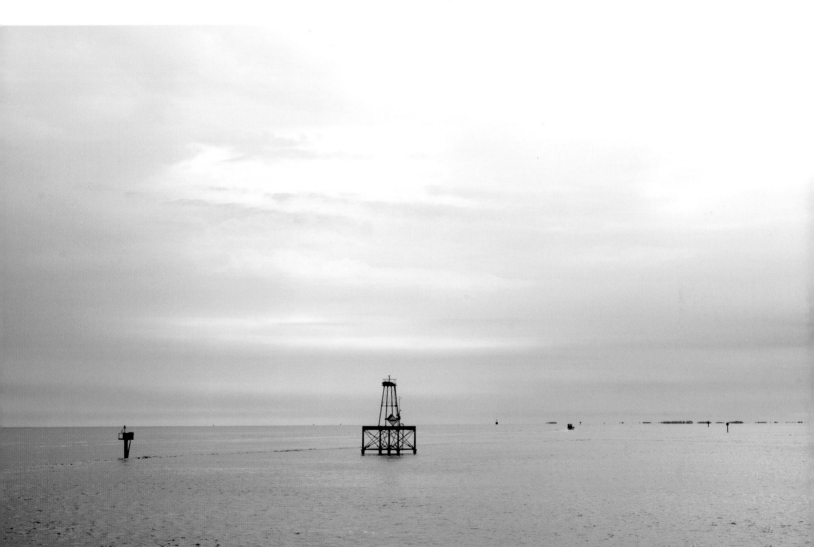

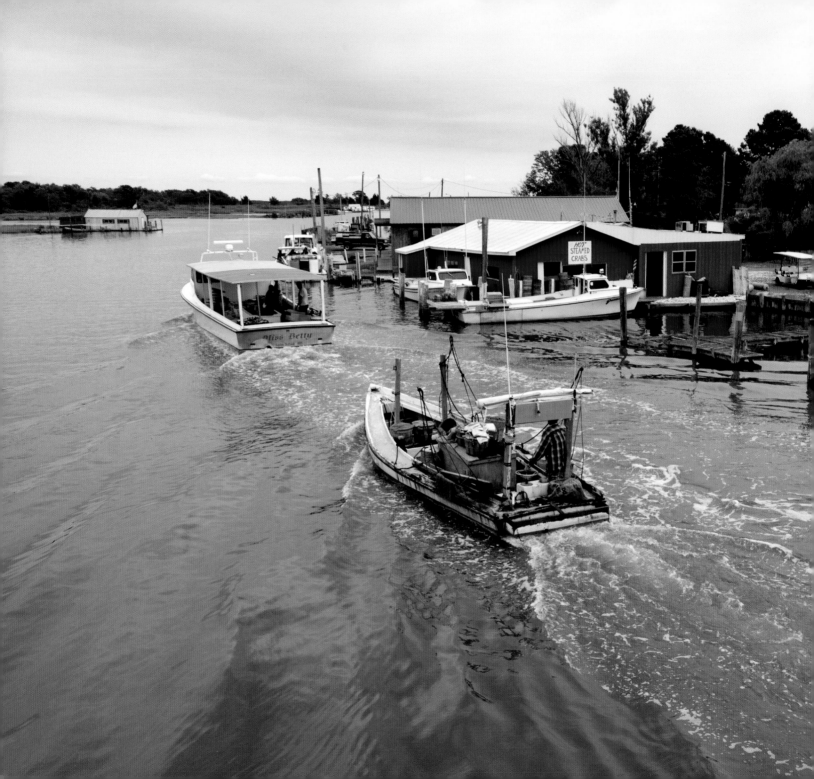

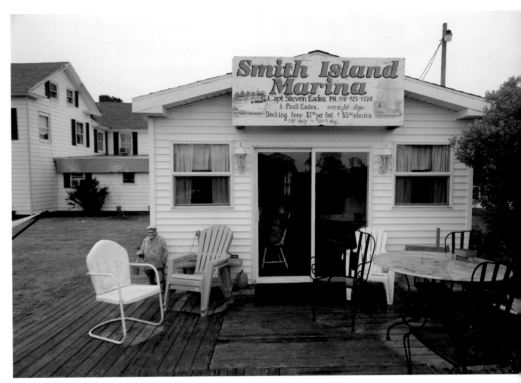

Smith Island.

Crab sorting facility in Tylerton where soft shell crabs, also called peelers, are separated from the rest of the catch.

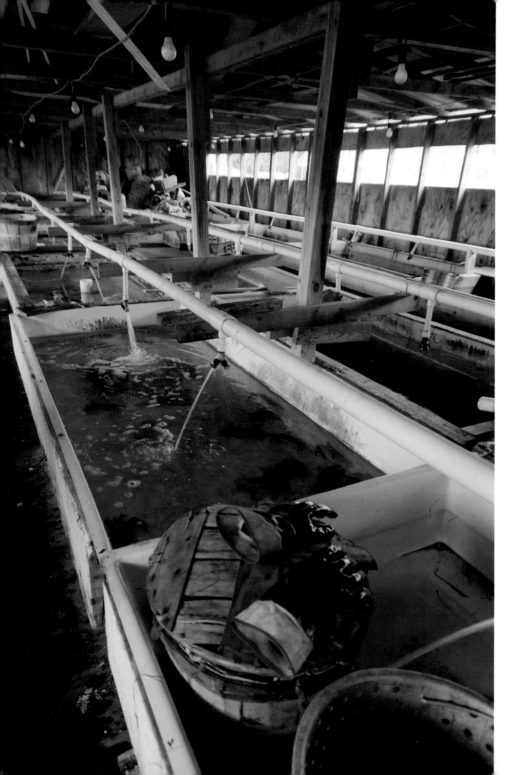

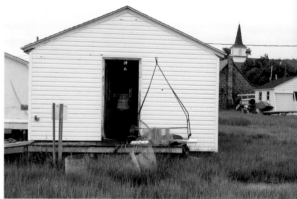

Tylerton on Smith Island is one of three villages and is connected to the other two only by water.

WORCESTER COUNTY

Worcester County was split from Somerset County in 1742. It sits on the eastern side of the Pocomoke River, and is the only Eastern Shore county that borders the Atlantic Ocean.

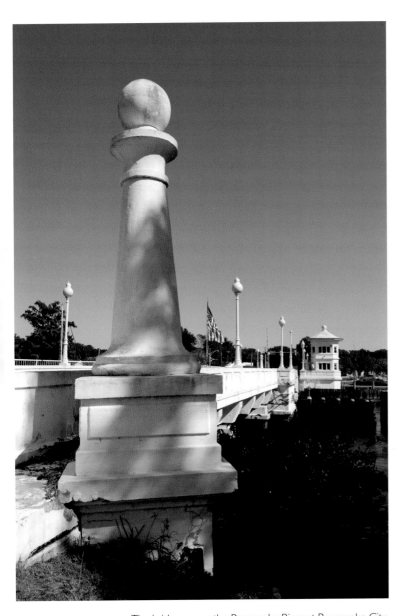

The bridge across the Pocomoke River at Pocomoke City.

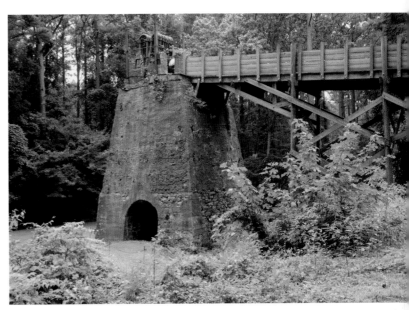

The Nassawango Iron Furnace, near Snow Hill, was built in 1830 by the Maryland Iron Company to produce iron from bog ore found nearby. It is part of the Furnace Town Living History Museum.

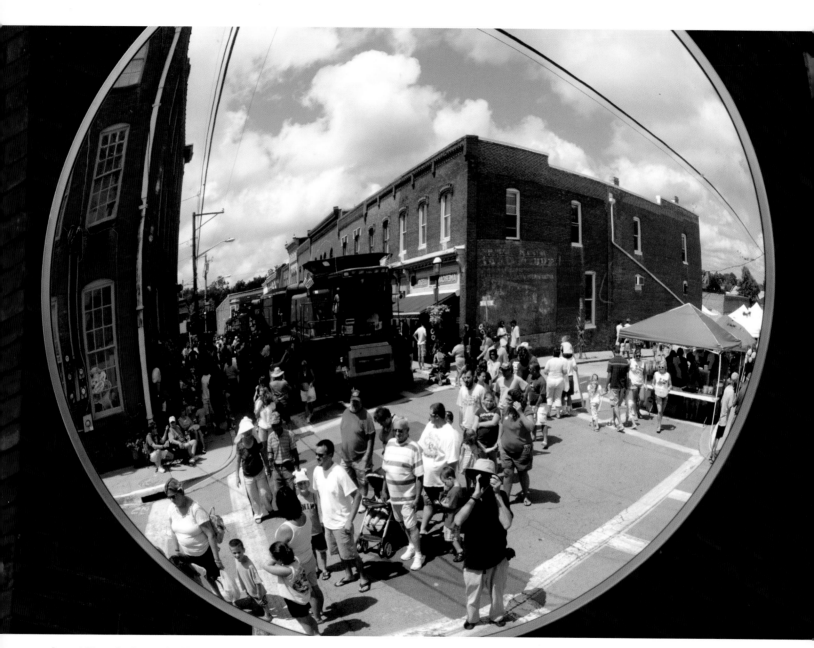

Snow Hill, on the Pocomoke River, is the seat of Worcester County. It is named after a section of London and was established in 1686 as part of the Calvert family's objective to create towns and advance trade along navigable rivers. Every year the town is the site of the Blessing of the Combines in August before harvest time.

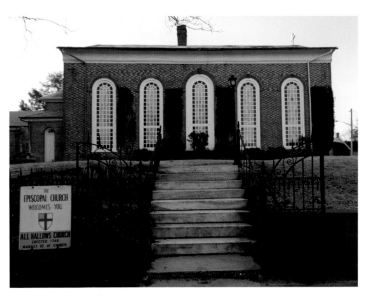

The Pocomoke River and the cypress swamps that give it its characteristic black color. In 1635, the river's mouth was the scene of the first known skirmish between the Virginia Company and the first Lord of Baltimore over who had rights to Kent Island.

All Hallows Church, Snow Hill.

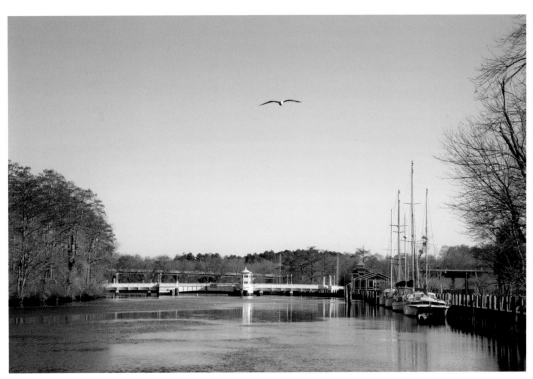

Boats tied up on the Pocomoke River, Snow Hill.

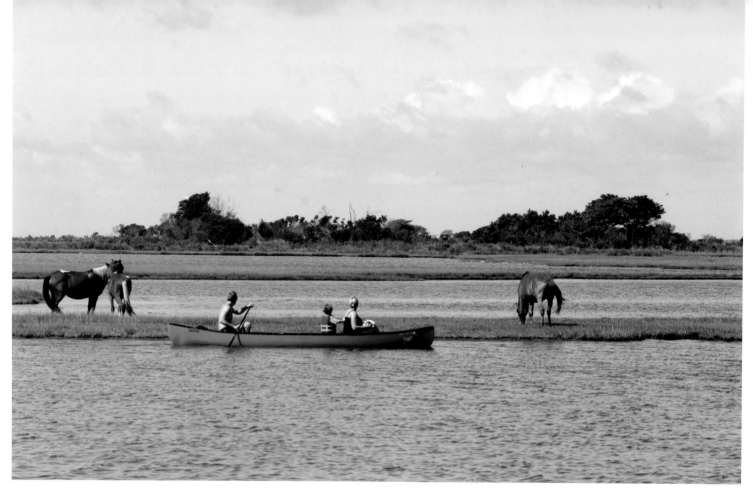

Assateague Island National Seashore. Assateague is a barrier island on the Atlantic Ocean that is protected from development by the states of Maryland and Virginia as well as the US government. It is known for its shore birds and wild ponies that wander about.

Antelo Devereux, Jr. is an architect and experienced photographer, who has been making images since he was 10 years old. His work has been shown in Pennsylvania, Delaware, Vermont, and Maine. He lives in Chester County, Pennsylvania.